Real Estate Photography

For Everybody

Ron Castle

AMHERST MEDIA, INC. ■ BUFFALO, NY

AUTHOR A BOOK WITH AMHERST MEDIA!

Are you an accomplished photographer with devoted fans? Consider authoring a book with us and share your quality images and wisdom with your fans. It's a great way to build your business and brand through a high-quality, full-color printed book sold worldwide. Our experienced team makes it easy and rewarding for each book sold—no cost to you. E-mail **submissions@amherstmedia.com** *today!*

Published by:
Amherst Media, Inc.
PO BOX 538
Buffalo, NY 14213
www.AmherstMedia.com

Publisher: Craig Alesse
Senior Editor/Production Manager: Michelle Perkins
Editors: Barbara A. Lynch-Johnt, Beth Alesse
Acquisitions Editor: Harvey Goldstein
Associate Publisher: Katie Kiss
Editorial Assistance from: Carey Anne Miller, Rebecca Rudell, Jen Sexton-Riley
Business Manager: Adam Richards

ISBN-13: 978-1-68203-302-9
Library of Congress Control Number: 2017939275
Printed in the United States of America
10 9 8 7 6 5 4 3 2 1

www.facebook.com/AmherstMediaInc
www.youtube.com/AmherstMedia
www.twitter.com/AmherstMedia

CONTENTS

ABOUT THE AUTHOR.
Ron Castle has been creating art since he graduated from the University of Arizona Graphic Design School in 1969 with a BFA in Commercial Art and Illustration. His interests have varied over the years, from graphic design, to oil painting, to photography. In the past thirteen years or so, photography has taken center stage in his creative life. After receiving an old Canon 10D DSLR camera from his son, Ron advanced his digital photography skills by completing several courses at the prestigious Santa Fe Photographic Workshops, utilizing numerous online resources, and through involvement with the Professional Photographers of America (PPA) organization starting in 2011. He earned PPA's coveted Certified Professional Photographer degree, and his very first entry into the International Photographic Competition in 2015 resulted in a Diamond Photographer of the Year award. As a result of the merits earned during the 2015 competition, along with 2016 competition merits, Ron earned PPA's Master Photographer degree in the shortest time possible! While Ron's portrait, wedding, landscape, and wildlife images have earned numerous awards, in the last few years he has focused his passion on architectural and real estate photography—and added more awards in print competition to his credentials. Additionally, his images and techniques were featured in *Texas Photographer* magazine and he taught a popular real estate photography workshop for the Texas Professional Photographers state convention.

INTRODUCTION

This book is an introduction to real estate photography and is primarily aimed at the reasonably experienced photographer who is getting into real estate photography for extra income or who aspires to make it a full-time business. However, as the title says, this is also a book that can help *anyone* (real estate agent, homeowner, interior designer, architect) who want to learn the basics of photographing a home and/or interior spaces. I'm purposely limiting the scope of this book to what you need to start developing your skills. Each time you photograph a home, you'll be applying lessons you learned from shooting the one before it. It's my hope that this book will speed up your learning curve considerably! Photographing interiors is not as easy as you might think, and it takes a lot of practice to produce consistently strong, impactful compositions for your clients.

The realities of the real estate business impose a special set of restrictions on a photographer, especially one who plans to make it a full-time career. Recording interior spaces, and being able to show how they relate is no easy task. Doing it in a way that's both artistically impactful and faithful to the realities of the property is even more difficult. Doing it efficiently enough to make it a career is more difficult still. I hope that this book will be a starting point that inspires you to continue growing your knowledge and honing your skills. One thing that should keep you motivated is that, if you do what's suggested, even your initial images will likely be better than those on most real estate websites!

This book is organized to provide you some basic knowledge about the business of real estate photography, the equipment you'll need to do the job, what and what *not* to photograph, compositional considerations, and a *suggested* post-processing workflow. The later chapters will consist of several sample home shoots. These images and their captions will hopefully provide some helpful suggestions and perspective on what a typical "real world" real estate shoot entails.

I want to make one final important point. There are different methods of shooting architecture/real estate. Some photographers use artificial lighting techniques with speedlights and/or strobes. Others, probably the majority right now, use high dynamic range (HDR) exposure-fusion techniques. Some use a combination of the two. Many different digital workflows are also used, depending on what capture methods are employed. This book is built exclusively around the HDR capture process and Adobe Lightroom as the primary post-processing platform. I believe this is the simplest and easiest way to get started with real estate photography, and the realistic HDR processing in Lightroom produces a very consistent, high-quality image. HDR fusion does have its limitations however, so if you plan on doing high-end residential or commercial architectural work, you'll eventually have to learn how to employ at least some interior lighting techniques.

1. BUSINESS REALITIES

Some basic realities of the real estate photography business environment are important to discuss. They dictate not only the kind of equipment you'll need and the technical skills you'll need to develop, but also how you will approach the photography itself. If there is one reality that dominates all others, it's the "need for speed." A slow real estate photographer may be able to make a little side money, but he or she will never be able to make a living with it. That's because another reality—the one that ultimately drives "the need for speed"—is the fact that you aren't going to be able to charge very much for each home you photograph. Your ability to make up for that with volume is going to determine your success. Any obstacle that interferes with your ability to photograph, post-process, and deliver your images for a residential property in a timely fashion is something you're going to have to overcome in order to be successful.

BUILD YOUR CLIENT BASE

Even though your ability to be as efficient as possible with your workflow will ultimately determine your success in the real estate photography business, the most important thing you'll need to do first is to go out and get the business! Your marketing efforts are crucial. This isn't a book on business marketing, so I'll just limit the discussion to specific things that you can do to build your realtor client base.

Before you can even approach a realtor for work, you're going to need sample images to show them. Start out by practicing on your own home or apartment, and building up a portfolio from there. Take it further by asking friends to let you photograph their homes. If you have realtor friends, offer to photograph some listings for free or for a substantial discount just to build your portfolio. I never advocate trying to compete with other photographers on price, so make it clear that this is strictly a temporary offer. Competing on price is a short-sighted strategy and ultimately self-defeating.

"If you have realtor friends, offer to photograph some listings for free or for a substantial discount just to build your portfolio."

Once you've built up your portfolio and feel confident with your skills, start out slowly by offering your services to just a few agents. It's not easy to get them to try you out, so you may have to do a few for free to demonstrate the difference good photos can make for their listings. Emphasize the fact that offering professional photos for their listings will differentiate them from their competition. Don't ever tell an agent that good photos will sell the home more quickly. The very first home I photographed a few years ago is still on the market—and that's probably because it's overpriced! The best photos on the planet are not going to make someone pay more than the market

value. What the agents *will* notice is that good photos get them more views on the website, and they'll know that because that information is recorded on the website. More views will eventually translate into more inquiries and visits to the home for face-to-face sales opportunities.

Once you've built up your business, you must make it your goal to deliver your images to the client the same day you shoot the property. If you're a full-time professional and you don't, you'll never catch up. Don't schedule more shoots than you can deliver, or your customer service will suffer. At a minimum, have all of your files completely ready for delivery by the next morning along with a customer invoice. The better you get at what you do, the more shoots you can schedule. If you fill a day with shooting and cannot get the post-processing done by day's end, you'll have to sacrifice shooting time the following day to make up for it. When you've reached a point where you can comfortably shoot and deliver enough houses each day to pay the bills, you've reached a big milestone! Building up the volume and keeping those assignments coming is the next challenge.

"Once you've built up your business, you must make it your goal to deliver your images to the client the same day you shoot the property."

One thing you absolutely need to do if you're going to start a business of any kind is network. This is really going to be crucial in the real estate photography business. You can't rely on a handful of real estate agents to keep you busy enough to survive. They aren't all created equal. Some will be real go-getters who provide you with fairly steady work, while others will only call you now and then when they have a high-end listing they're willing to spend a little extra marketing money on.

There's no magic number, but you don't want to "quit your day job" until you've built up a client base that's big enough to keep work coming at you reliably enough to pay the bills. This process of building your client base is not going to happen overnight, so be persistent and patient. It may take a couple of years or more to build up an adequate number of clients. One thing you can do to speed this process up is join a service organization like the Rotary Club or Lions Club, and/or even join your local board of realtors' organization as a vendor (if they allow this). You also need to be active in your local Chamber of Commerce and other community organizations. This involvement can be very rewarding to you personally and will ultimately pay off for your business.

One last suggestion (which may sound a little extreme at first): consider getting your real estate license! If you already have one, then you know what the advantages are. Your networking and photographic opportunities are going to be much better, and your ease of access to properties will give you a competitive advantage over other photographers as well. It can also make the transition from one occupation to the other much easier. One of the most successful real estate photographers I know, Randy Henderson (from the Springfield, MO, area), started out as a realtor and still maintains

his license! He shoots five or six properties on average per day, seven days a week! I don't know if everyone would want to work that hard, but he makes some very good money!

DEFINE YOUR MARKET AREA

Another "reality" of the real estate business is that you'll need access to a real estate market big enough to support your business. If you live in a large metro area, this won't be a problem, but deciding what part of that market you can efficiently and affordably service will still be necessary. If you're going to photograph three or four residences a day and have time to do the post-processing and image delivery by day's end (which is what you'll have to do), you can't be wasting too much time driving long distances between jobs. In a smaller market, you may need to expand your territory to include surrounding communities within an hour's drive of your location. However, you'll probably need more than one shoot scheduled to justify that drive. Otherwise you'll need to charge an appropriate travel fee.

You can start researching your market online by looking up how many homes are currently listed for sale in your area. You can also get a feel for the "quality" of the market by paying attention to the selling prices of the homes in your area. You may be able to find some statistics for your market from local real estate sources. Every market is different, but how much you can charge and also how much money you need to make to make a good living is going to be directly related to the home prices in your area. No matter what your market is, a real estate agent is not going to spend money on professional photography unless the commission they'll earn from the listing will justify the fee.

"In a smaller market, you may need to expand your territory to include surrounding communities within an hour's drive of your location."

FREE DOWNLOAD. Some of the upcoming chapters feature screen shots. Due to the constrictions of page size, this may result in small type that is challenging for some readers. To download a PDF with large copies of each screen shot (and corresponding page numbers), please visit: **www.amherstmedia.com/downloads.html**

2. EQUIPMENT

I want to start this section by addressing something that I'm sure experienced photographers reading this book are scratching their heads about. The subtitle, "Boost Your Sales with *Any* Camera" may sound a little crazy. Clearly, in order to produce professional-level images, you're going to need a professional grade camera. However, for those readers who just want to create the best images they can with the cameras they already have (including cell phones), I'll be addressing their needs as we go along. You'll see that you can create some very acceptable listing photos with a point-and-shoot camera or a cell phone—as long as you follow the other suggested techniques in the book. You'll also see that the overall cell phone workflow is almost the same as that of a high-end DSLR camera! The camera you use is certainly important, and it will place an upper limit on the quality of the image files you can produce. You're certainly not going to build a professional career using a cell phone. But if you use the techniques in this book, I think you'll be pleasantly surprised by the results—regardless of what camera you use.

TRIPOD

There are a few things that are required, while others are "nice to haves." I'll start with the one piece of equipment you can't do serious architectural work without: a tripod. There's no way to do an acceptable job of real estate photography without a stable shooting platform. This is especially important to you cell phone shooters out there! There are lots of brands and different styles of tripods on the market, and they all have features that make them better at one type of photography or another. Most of us do more than one type of photography, so you'll have to determine which tripod does the best overall job for your situation.

Tripods also come with pretty dramatic price differences. In my opinion, as long as the tripod is able to bear the weight of your camera and is sturdy enough to keep it totally still during a long exposure it will work for real estate purposes. Most of the other features (like portability and setup) will be a matter of personal taste—and you'll make those determinations as you get more experience. That said, one tripod variable that can make a big difference for your real estate work is the camera mounting head. There are many different types and some are easier to manipulate than others. We've already talked about the need for speed, so this should be your top priority when picking out a tripod head.

▶ **BALL HEAD** *(facing page, top)*. I started out using a ball head on a Manfrotto tripod; it's one of the most popular, all-purpose heads out there. You can move the head (and your mounted camera) through each axis in one motion and it has one knob that can tighten it all down with one twist. This is a fairly inexpensive option and a good

choice as an all-purpose head. However, as I gained more experience shooting interiors and realized the extreme importance of having the camera *absolutely level* for each shot, the ball head proved to be very frustrating to use. The importance of keeping the camera level will be discussed more thoroughly later, but doing so will save you a *lot* of time in post-processing. Since you'll need to check and correct your level before each and every shot (not all floors are created equal), being able to do this quickly is a must.

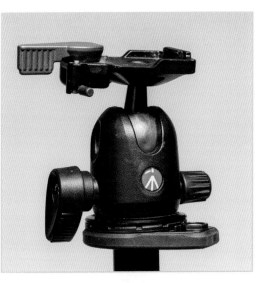

▶ **GEARED HEAD** *(middle right)*. For speed, I found that a geared head is absolutely the best option! The geared head has a separate screw in/out adjustment for each axis (vertical, horizontal, and yaw) which makes fine-tuning it to level a breeze. After you've got the camera and tripod level, it allows you to rotate it the on the yaw axis (left to right) with precision to fine-tune your composition without having to re-level. As always, there are different quality levels of geared heads, but I've found the least expensive option that Manfrotto makes works just fine for my purposes.

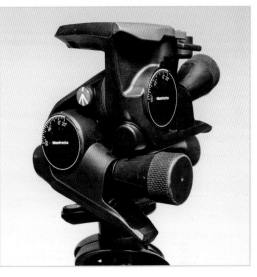

▶ **CELL PHONE MOUNT** *(bottom right)*. This photo shows a sample tripod mounting bracket that works with most modern cell phones, including iPhone and Android models. This universal model made by Vastar is very solidly built and sells for under $10. It can be mounted to the geared head discussed above (or to any other tripod head) by simply attaching it to the tripod's quick release mounting bracket plate.

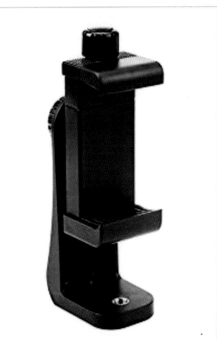

▲ CELL PHONE OR POINT-AND-SHOOT TRIPOD. This light-weight, 60-inch tripod retails for about $25 and the adjustment arm can quickly level a cell phone or point-and-shoot camera. One feature of this tripod is the fixed position legs that can be tightened down so that, once the phone is properly leveled, the setup can be moved around quickly without having to re-level the camera each time (as long as you place the legs flat on a level floor). Be careful outside in windy conditions! You may need to put some kind of weight on the tripod to keep it from moving or blowing over.

WIDE-ANGLE LENS. The next must-have for shooting interiors is a wide-angle lens. You'll be shooting in some very tight quarters at times, and you'll have to have a lens capable of taking in as much as possible without creating too much distortion. For a full-frame sensor DLSR (digital single lens reflex camera body), a focal length of 16–17mm is as low as I would go. On a cropped sensor DSLR, the equivalent coverage can be achieved with around a 10mm focal length. There are wider angle lenses on the market (billed as "ultra-wide angle"). These are popular with some photographers because of how they can exaggerate the size of a room. Personally, I find the image distortions to be very distracting. (I owned an 11–24mm lens for a time but have since sold it.) Canon and other camera makers all offer zoom lenses in the 17–40mm and 10–22mm range to cover most wide-angle needs.

The side-to-side field of view (FOV) for a 17mm lens is approximately 93 degrees. By comparison, the FOV for the iPhone 6S Plus is approximately 73 degrees, which is equivalent to having a 30mm lens on a full-frame DSLR. This is not ideal for real estate interiors, but it's one of the limitations you'll have to deal with. When it comes to fixed-lens point-and-shoot cameras, there are simply too many variations out there for me to give any generalizations. If you're making a purchasing decision, check the maximum FOV before you buy.

▼ TILT/SHIFT LENS. A tilt-shift lens (sometimes referred to as "perspective control"

lens) is very much worth considering if you plan a career in architectural photography. This type of lens allows you maximum control over your compositions by allowing you to "shift" your image up, down or sideways without having to change your leveled camera position. This lens can be a "must have" for shooting tall buildings. Manufacturers offer several focal length options for these lenses, but for a good all-around focal length, I recommend the 24mm.

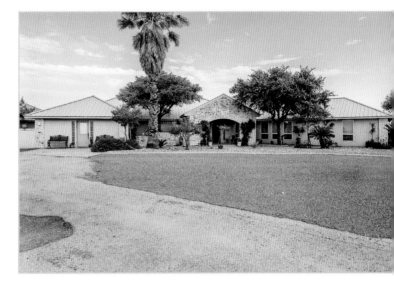

I've used a 17mm tilt-shift, but had a lot of problems with lens flare from bright windows.

▶ ▼ TILT/SHIFT LENS: FRAMING CHOICES.

The tilt-shift lens projects a much larger image over the sensor, giving the photographer the flexibility of choosing which part of that larger image to capture. The image above, a Canon 24mm tilt-shift capture, shows the home as captured with the lens in its neutral position (just as a regular 24mm lens would capture it). The image below shows the same view after the lens was shifted *up* to reveal more of the sky and less of the uninteresting driveway!

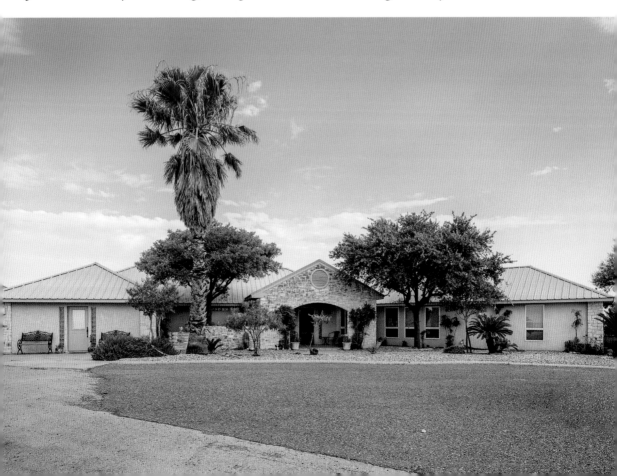

▼ **CAMERAS.** Let's talk about cameras. I'll talk about them more in terms of their features rather than specific models, since there are just too many brands and options out there to go into even a fraction of them. There are some features that I consider "must haves" for real estate particularly. Of course, most people buy a camera to cover as many different situations as possible, so blending those needs is something only you can do. For the aspiring real estate pho-tography professional, a digital single lens reflex (DSLR) camera body is a minimum requirement. These cameras that allow the user to look through the lens with the use of a mirror placed over the sensor. They also allow you to switch lenses depending on your needs. Some manufacturers are also making big progress with mirrorless cameras recently, and these cameras are quickly becoming very popular with architectural photographers. Their small size and light weight, along with electronic viewfinders that allow the photographer to "see" the camera's real time exposure and focus, are huge selling points.

There are two basic categories of DSLR cameras that you're likely to use. These would be full sensor and cropped sensor cameras. There are advantages to each, and either will work just fine for real estate shooting. The basic difference between them is the size of the digital sensor. A full-sized sensor is going to be the same size as the 35mm image projected onto it by the lens. A "crop" sensor is going to be smaller than the 35mm image, so the image captured is going to appear to be magnified by what is usually around 1.6 times. When you buy lenses, this has to be taken into account.

Cropped sensor cameras are generally cheaper, and the file sizes are smaller as well. Since most real estate imagery ends up on the web or printed in small newspaper ads, the need for large, printable files is not usually critical. Thus, the cropped sensor camera is actually an advantage in real estate—especially when it comes to the post-processing workflow where smaller file sizes yield shorter processing times! However, as you progress in the real estate field and start doing more high-end homes, you'll need to provide better quality files to your clients. To do this, you'll probably end up with a full-frame camera eventually.

RAW FORMAT. The most important feature in a real estate camera is the ability to shoot in RAW format. Most point-and-shoot cameras do not offer this capability—and this includes most cell phones (at least at the time of this writing). In chapter 3, I'll discuss how you can now get RAW files from some of the newer iPhone and Android cell phones however. The reason this is critical to your real estate work is that a RAW file contains *all* of the digital data captured in each image and allows much more latitude for your post-processing. Using a RAW format is the only way to change the color balance in post-processing—and getting the color balance correct is one of the most critical and challenging aspects of making a good real estate image! The quickest way to tell a professional real estate photo from one done by an amateur is by the telltale yellow color cast on the amateur's JPEG images (caused by the color temperature of incandescent light bulbs). There will be more discussion on that later.

LIVE VIEW. Live View/focus/capture capability is another feature that I personally consider a must-have. It's not absolutely critical, like the RAW capture feature is, but it's extremely helpful in getting your shot set up and composed properly. It's also very helpful in being able to visualize your exposures during the HDR capture process. This is enhanced even more if the camera has a "highlight alert" feature, which will instantly reveal areas in your image that are overexposed with no detail. Using certain overlay features in the Live View mode (like the rule of thirds grid or other compositional tools) can also help with lining up verticals and horizontals in your shots.

▼ **ARTICULATING SCREEN.** A camera with an articulating (adjustable) back viewing screen is also a great help, since the required camera angle for an image often makes for an uncomfortable viewing angle.

Articulating Screen

◄ **DRONES.** In today's real estate market, drones have become very common and provide a way to make extra money on your residential and commercial jobs. The FAA has recently simplified the licensing process for the commercial use of unmanned aircraft (drones), and the quad-copters available right now offer some easy-to-use, all-in-one photography options. The built-in cameras keep getting better, and some are now capable of shooting large, RAW files and 4K video! Realtors are asking for this service more and more now, especially for homes (like the

Join a domain	
Join Azure AD	
Edition	Windows 10 Pro
Version	1511
OS Build	10586.633
Product ID	00330-50214-48763-AAOEM
Processor	Intel(R) Xeon(R) CPU E5-1650 v4 @ 3.60GHz 3.60 GHz
Installed RAM	32.0 GB
System type	64-bit operating system, x64-based processor
Pen and touch	Pen support

Change product key or upgrade your edition of Windows

Read the Privacy Statement for Windows and Microsoft services

Read the Microsoft Services Agreement that applies to our services

Read the Microsoft Software License Terms

Support

Manufacturer	SolidBox
Website	Online support

Related settings

one shown below) that have large lots in unique landscapes that are difficult to portray with ground-level photography alone. Most requests are for stills, but short aerial videos are also becoming popular. You can set yourself apart from your competition by offering this service, and I can tell you my first drone paid for itself in less than three months!

▲ **COMPUTER.** The final piece of essential equipment needed for your digital workflow is, pretty obviously, a computer! It would be impossible to go into depth on this subject (especially since my depth of knowledge is pretty shallow)! The only point I want to make on the subject of computers is to reiterate the importance of speed in the overall real estate photography workflow. This means that you must place as high a priority as you can possibly afford

on getting a speedy, reliable computer! I just upgraded my computer a few months ago, so the specs shown in this screenshot show the latest capabilities available at the time of publication—but I'm sure these will be outdated very soon. In addition to a fast computer, you also want to make sure you have a good monitor(s) and software to keep them color calibrated. If you're doing work for a designer or builder, and color accuracy is required for their images, you *have* to keep your monitors color calibrated.

"You can set yourself apart from your competition by offering this service . . ."

3. CAPTURE BASICS

Okay, we're loaded up with all the right equipment, and it's now time to go out and take some photographs! Let's discuss some of the basics of the capture process, including camera setup, camera operation, and the essentials of setting up your shots in the home. Whatever camera you're using, you need to read the following discussions. The basic principles are mostly the same, but I will address some specific differences and workarounds for cell phone and point and shoot camera users at the end of this chapter.

▼ **BASIC CAMERA SETTINGS**. This image of my camera's back screen shows the way I have my camera set up for virtually every real estate shoot. I set this up before I leave my studio, and it doesn't change for the rest of the day! By having a standard setup like this, you avoid the danger of changing an important setting during a shoot and then forgetting to change it back. The only thing that's going to change from shot to shot is the shutter speed, depending on the exposure needed.

I always have the ISO set at 400 in order to keep the shutter speeds as high as possible and the aperture is always set to f/8.0 to give me maximum sharpness with the lens as well as maximum depth of field. We've already discussed the necessity of shooting RAW, and since my camera holds two memory cards, I set them both up the same way. The second card is set to record the same image as the primary, so I always have an in-camera backup.

"The only thing that's going to change from shot to shot is the shutter speed, depending on the exposure needed."

You'll notice I have the shutter release set to a 2-second delay. If your camera doesn't have this feature, I recommend getting a remote shutter release of some kind. This delay (or remote release) allows the camera movement to settle down after the shutter button is pressed to make the sharpest image possible.

I also keep the white balance set to automatic since it usually gives the image a reasonably good starting point depending on where the shot was focused. Since each room is going to be unique with regard to light sources, it doesn't do any good to set the white balance to a manual setting in hopes of being able to synchronize all the images later.

M	1/30	F8.0	⁣ISO 400		
¯3..2..1..⓪..1..2.⁺3		💱±0	📷☰		
📷S	AWB	WB +/−	📷OFF	▸1	RAW
ONE SHOT	⊡	📷2	▸2	RAW	
Self−timer:2sec/Remote control					

▲ **LIVE VIEW**. As mentioned earlier, I use the Live View mode for shooting all my real estate work. It's not something that's absolutely necessary, but I find it really helps me to be able to see my composition on the back of the camera rather than looking at it through the viewfinder. It also makes it easy to choose the right exposure settings for the HDR sequence.

▶ **HIGHLIGHT ALERT**. I use Live View in conjunction with the highlight alert feature to determine when I've got all detail in my highlights. At a minimum, it allows me to be sure I have detail in the windows, and it also lets me know if light fixtures are showing as much detail as possible.

"I find it really helps me to be able to see my composition on the back of the camera rather than looking at it through the viewfinder."

▶ **LEVELING THE CAMERA**. I've mentioned before the importance of getting the camera level before each shot, so if I can't see the bubble level on my tripod well enough to do it, the built-in electronic level is a great back-up. In my camera, the built-in level takes time to call up in the menu system, and it's also a little difficult to get just right. For those reasons, I normally only use it when I have to. The reason you want to have the camera level is that it guarantees that all of your verticals are straight. Getting the verticals right is the holy grail in archi-tectural/real estate photography. You can do a lot of things wrong with a shot, and maybe get away with it, but having your

verticals out of whack is totally unaccept-able! It is possible to correct them during post-processing, but this can be time-con-suming, and it can also cause you to lose some of your final image by forcing you to crop distorted areas.

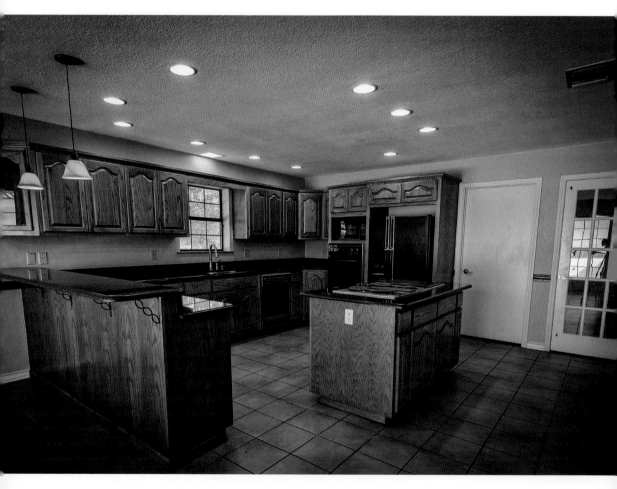

◄ **DISTORTED VERTICALS** *(facing page, bottom).* This photo shows you how bad an image looks when the verticals are not straight.

▼ **BETTER VERTICALS** *(below).* This photo shows the verticals as they should be, and you can see what a big difference it makes in the overall impression.

Another consideration when setting up your camera for a shot is the camera height. This photo also illustrates that point. The rule of thumb when setting your camera height for a given room is that it should be set approximately 20 inches above the highest dominant horizontal surface in the

"You want to be able to see at least some of the top surface of the counters without including any more ceiling area than you have to."

room. In this kitchen, that surface is the tops of the counters. You want to be able to see at least some of the top surface of the counters without including any more ceiling area than you have to. You can see that if your camera height was lower than the counter tops, you'd only see the edges of them and you wouldn't be able to show the stove top and kitchen sink area.

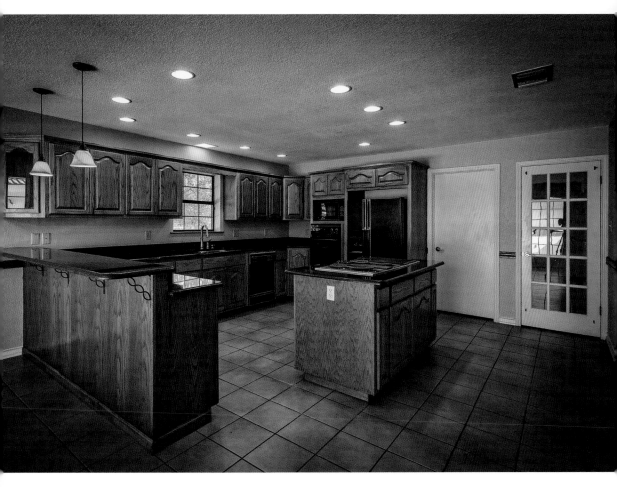

◄ **CROOKED HORIZONTALS.** Even when you have the verticals in a room set perfectly, you can see from this image, that prominent foreground horizontals can be very distracting if they aren't shot with the bottom edges parallel to the bottom of the frame.

▼ **IMPROVED HORIZONTALS.** As shown below, it only takes a slight rotation of the camera on the horizontal axis (after it has been leveled) to line up the chest and make a much more pleasing image. The verticals will stay straight while you rotate the camera, but the horizontal line can be adjusted as required.

► **CROOKED HORIZONTALS.** The same thing applies here—even though it's not nearly as dramatic.

▼ **IMPROVED HORIZONTALS.** You can see how much more impactful this shot looks. The main point to be made here is that if you're going to set a prominent horizontal element out of parallel with the frame, make sure it's done dramatically enough to show that you intended to do it that way. When it's just slightly off, it looks like you didn't take the time to make a good composition. It results in a mediocre image.

▼ ► EXPOSURE BRACKETING FOR HDR.
Once you've got the camera properly set up for the shot, it's time to shoot four to five exposures of the scene to capture the entire range of light from the lightest to the darkest as shown here (2 to 3 stops under, 1 stop under, 1 stop over, 2 to 3 stops over). To change the exposures, simply change the shutter speed (not the aperture)! In order to see your starting composition and select a good focus point, you always want to start with the lightest exposure first.

You then move through the range in 1- to 2-stop increments until you've covered the exposures. When you no longer see blown highlights (as shown by the highlight alert), you've got all the detailed exposure information you need to make a great image of that room. You may end up taking more than five exposures to get all the highlight detail, but you can discard the images at the end that don't quite get it all before you process the HDR file. I never use more than five images for the HDR source files.

ISO 400, f/8.0, and 1.0 second

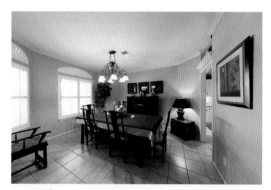
ISO 400, f/8.0, and .4 seconds

ISO 400, f/8.0, and 1/13 second

ISO 400, f/8.0, and 1/40 second

ISO 400, f/8.0, and 1/80 second

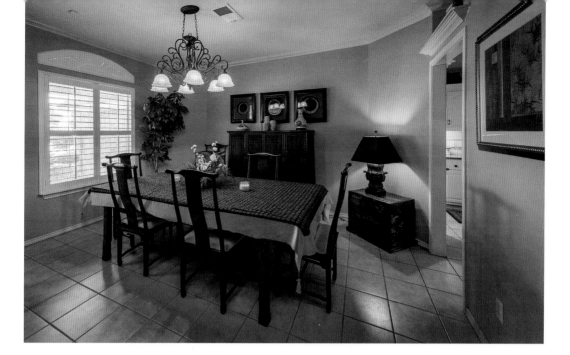

▲ **FINAL HDR IMAGE.** This is the final HDR image. Notice the exceptional detail in the light fixtures as well as the outdoor scene through the windows. When taking exterior shots, be mindful of the wind. If you take multiple exposures for HDR (especially at slow shutter speeds) while the tree limbs and leaves are blowing around, the final image is not going to look good. When it's windy, I usually opt for a single shot at a

DON'T OVERSHOOT. It's easy to get carried away and take too many shots. If you do, you're just creating unnecessary work for yourself. Most multiple listing service (MLS) websites used by realtors only allow 20 to 25 images per listing, so if you take many more than that, you're wasting valuable time. You only want to take enough images of the home to spark interest among online buyers—to get them off their couches to look at the home in person.

higher shutter speed that's just slightly over-exposed. That way I have maximum leeway to bring out shadow detail without creating excessive noise.

POINT-AND-SHOOT CAMERAS. There are just too many point-and-shoot cameras on the market to make specific suggestions. However, the only part of the overall capture process that's unique to each camera is how you change the exposures. Some cameras offer full manual control; others let you vary the exposure up or down from the camera's automatic setting (with the camera choosing what variables to change—ISO, shutter speed, or aperture). If you're serious about shooting real estate, invest in a camera that allows for the highest degree of manual exposure control. The goal is to produce four to five exposures (ranging from dark to light) that can be processed with the techniques in chapter 4. If you aren't able to do that, the only other option would be to use a built-in flash (which most

point and shoots have) to make the best overall exposure you can. As long as you've followed all of the other capture principles discussed, you'll still end up with a much-improved photo, even if the exposure and tonalities aren't ideal.

CELL PHONE CAMERAS. Even though cell phones have built-in limitations on their sensor size (and quality) and lens options, one thing they do have is tremendous operational flexibility! Through the use of third-party applications, iPhone and Android phones can mimic some of the features you find on expensive DSLRs. You might be surprised (as I was until recently) that you can even get a universal DNG RAW file from either type phone with the right app! You can also attain full control over the exposure process using both ISO and shutter speed changes.

▼ **SUGGESTED APPS.** The application I use for my iPhone 6S Plus is ProCam 4; the

app that seems to be the consensus pick for Android (with similar features) is FGAE Photography's Camera FV-5. As you can see from the screen shots *(bottom left, top and bottom)*, neither one breaks the bank—but what a difference they make to what you can do with your cell phone!

▼ **PROCAM 4.** I'll use the ProCam 4 app and my iPhone to discuss the basic features you can use. In **image 1**, the left side of the screen shows the options—such as screen overlays, format sizes, and shooting modes. On the right side you can choose the RAW and TIFF file formats, auto exposure bracketing, and in-camera HDR (not recommended for our purposes).

You can also see another *very* useful feature that allows for constant monitoring of

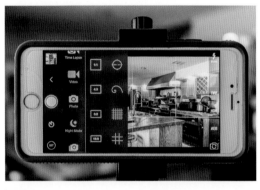

image 1

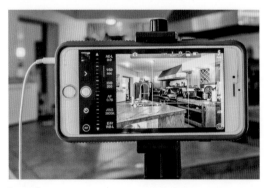

image 2

the camera's leveling status. Notice the yellow horizontal line at the bottom one-third line. The horizontal segments on either side of the middle vertical lines indicate that the verticals are straight. The middle segment shows the horizontal level status. This a huge help for cell phone users!

Image 2 *(facing page)* shows the shooting interface, allowing for manual adjustment of the ISO or shutter speed and the option of using auto exposure with exposure compensation changes. To change an exposure parameter, simply tap the one you want to change (shutter speed or ISO) and then slide your finger up and down to vary the setting.

Also, notice the ear bud cord coming out of the phone. As mentioned, I use the 2-second delay on my DSLR to minimize camera shake from the shutter press. Avoiding camera shake with the iPhone is even more difficult, given its light weight, so I use the ear bud's volume button as a remote shutter release! Either volume button will work, but the pause button in the middle does not trigger the shutter. I don't think you can get a really crisp image with the phone without using the remote.

▶ **FINAL ANALYSIS.** The images to the right show the results from capturing five exposures from the same location using my Canon 5D Mk III (top), the iPhone shooting RAW (center), and the iPhone shooting JPEG (bottom). They were all processed in Adobe Lightroom with the techniques discussed in the next chapter. Close examination at a one-to-one pixel ratio reveals significant differences between them.

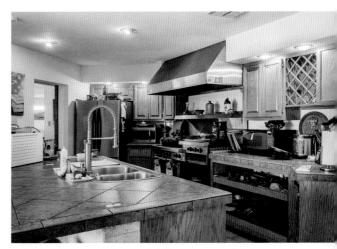

HDR image from Canon 5D Mark III RAW files.

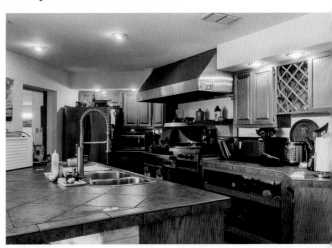

HDR image from iPhone 6s RAW files.

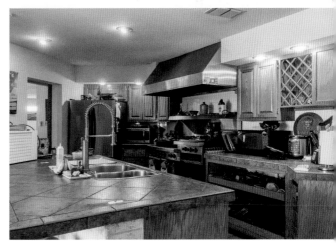

HDR image from iPhone 6s JPEG files.

4. POST-PROCESSING

As I noted in the introduction, my post-capture workflow is primarily built around Adobe Lightroom Creative Cloud (CC) and a little bit of Photoshop when required. In a typical 25- to 30-image shoot, I might take one image into Photoshop to clone out a reflection of my camera in a bathroom mirror. However, in most cases, I try to avoid that situation by using proper camera placement. For the purposes of this book, I assume that the reader has at least a working knowledge of Lightroom basics. I'll be covering the specific tools and options I use for organizing and processing my HDR real estate images.

You might ask, "Why Lightroom?" As noted, the key to success with real estate photography is being fast, efficient, and organized. Adobe Lightroom excels in all three. Additionally, the non-destructive (RAW file) editing process allows a lot of latitude for correcting mistakes. That said, the main reason I'm sold on Lightroom as a complete, one-stop editing workspace is the relatively new addition of their 32-bit, high dynamic range (HDR/exposure fusion) process! Lightroom does a great job of delivering a realistic image file that's just as editable as the originals, and it allows for crucial color temperature corrections that can only be done to a RAW file. If all this wasn't enough, the latest update to Lightroom also introduced another phenomenal feature called the Self-Guided Upright tool. This tool is an add-on to the previous Upright Module and it allows very easy corrections to verticals as well as horizontals. This will be demonstrated later in the chapter. So, let's get started.

▼ **IMPORT DIALOG BOX.** The screenshot below shows the Import dialog box. In the

upper left corner you see the source of the images is F:\EOS DIGITAL, which is the camera's compact flash card. In the center (directly to the right) I've highlighted in yellow Copy as DNG. This is one of the four import options available. The DNG is an Adobe file format that provides all camera manufacturers the ability to convert their proprietary RAW files into a more universally usable format. There are many other benefits to using DNG files, but we don't have time to go into them in this book. You always have the option to convert your RAW files into DNGs in Lightroom, but I like to get it over with during the import process. Even though a RAW DNG file is the ideal format to use for all post-processing, the Lightroom HDR process can still use JPEGS from any camera to do its magic. The file that's produced from the JPEG HDR process will be a DNG, but it won't contain as much information as a true RAW DNG file. You'll still be limited on what you can do with your white balance issues.

I also want to point out a few other things I do before importing my files. On the right side vertical panel you see some other items I highlighted in yellow. Starting at the top is the Develop Settings window. I have a very simple custom develop setting I created that I apply to *all* my images upon import, not just to real estate photos.

▶ **ADDITIONAL IMPORT SETTINGS.** In addition to the standard Lightroom import settings, I simply add Lens Corrections. Note the two checkmarks next to Remove Chromatic Aberration and Enable Profile Corrections. These settings remove the multi-colored halos caused by certain lenses

and apply corrections to remove any known distortions associated with the specific lens you used. These settings can be applied at any time, but I like to get it all over with upon import. I called my import preset "Ron's Basic Import" and saved it as a Custom Preset. Another thing I always do before importing is add keywords to the files, including the name of the real estate agent who hired me, the address of the property, and also the words "real estate." You can add any other keywords you deem necessary for your workflow. As far as file locations go, you can see how I do it (highlighted in the lower part of the panel), but everyone will have their own way of organizing their hard drives.

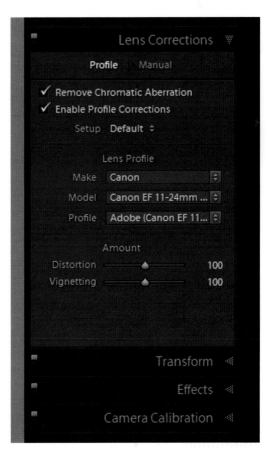

▶ ▼ SELECT AND PROCESS HDR. As discussed in chapter 3, I generally shoot four to five different exposures for each setup. In **image 1**, you can see five images selected (bottom left of strip, circled in red) and with larger thumbnails shown in the center of the screen. The highest exposure is selected (top left, circled in red). In the Histogram for this image, located in the upper right corner of the Library module screenshot, I added a red arrow pointing to the gap in the darks area (left edge of the histogram). The histogram shows the distribution of dark and light pixel information in the file. The far left side of the histogram shows the darkest blacks, while the right side shows the brightest whites. The gap between the left side of the box and the left side of the pixel information indicates that this file has all the dark and shadow information possible in the scene but a lot of the white information is lost in this exposure.

In **image 2** you see the just opposite. All of the available bright white information is captured in this dark exposure, but the blacks are almost completely lost. The files in between the two extremes contain varying amounts of light and dark information.

To show the complete range of light and dark in one image, we need to fuse the five files together using the HDR process. With all the files selected, either right click with a mouse or select Photo > Photo Merge. Then choose "HDR" as shown in **image 3**.

The program will then create a crude preview of the final HDR image (**image 4**). This process usually takes 15 to 30 seconds, depending on your computer's speed. Once it shows up, you'll also see the options in the upper right circled in red. These are options I recommend always leaving checked. They are "sticky" settings, so once they're selected, they'll stay that way forever unless you change them. Even though you should be using a tripod, I still recommend checking the Auto Align box and the Auto Tone options. For me, this usually creates a good starting point for processing the final HDR image.

I've highlighted the None button in yellow under the Deghost Amount box, because I don't recommend ever using this setting. It's there in case you have something moving through the scene between takes. It's supposed to make a choice

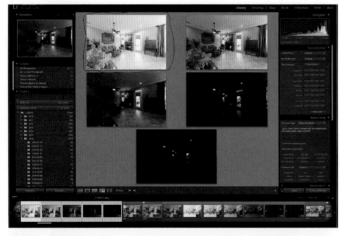

image 1

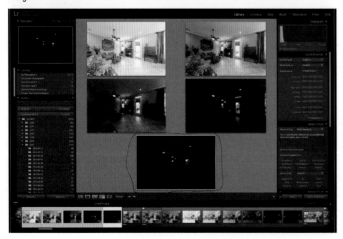

image 2

on which moving image to use for the final HDR. In my opinion, it doesn't work that well to begin with; even when it does, it's very time-consuming.

If you're satisfied with the HDR preview as shown, then click the Merge button on the bottom (outlined in blue).

The program then produces the final HDR image (in about 20 to 30 seconds) and places the new file next to your source images as an "HDR.dng" file as shown in **image 5**. It's highlighted in white, and I've circled it in red on the bottom thumbnail strip. This is now a 32-bit file containing 20 stops of exposure information—as opposed to 10 stops of exposure in the original 16-bit source images.

CHECK THE SORT SETTINGS.
In the View menu, if you don't have your images sorted by capture time or file name, the program sometimes defaults to listing them in the order added. If that's the case, your new HDR file will be added to the end of the image strip (out of sight), and you'll be wondering where the heck your HDR file went! If the image doesn't show up after the HDR processing is finished, you need to set the files to sort properly.

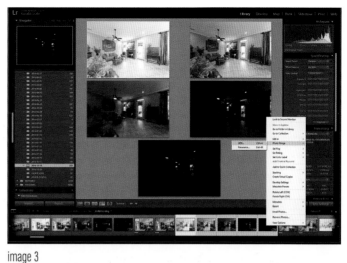

image 3

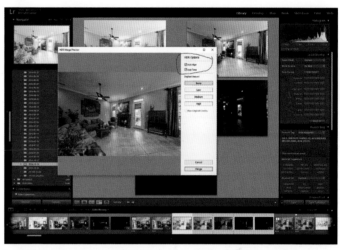

image 4

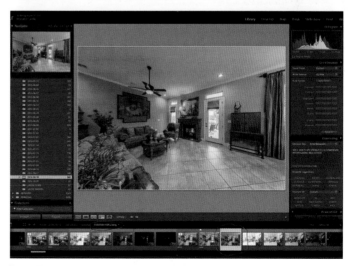

image 5

▲ FILE SIZE. Just to demonstrate what I mean by a 32-bit file, this illustration shows the source files and the new HDR file in their locations on the hard drive. You can see by the file sizes that the individual 16-bit source files range from 19MB in size to 26MB, and the new HDR file, 87MB, is nearly the size of all five combined! One important takeaway from this is that when you're sure you don't need the source files any more, be sure to erase them from your hard drive. Otherwise, you're going to fill up a hard drive very quickly! I only do this after I've delivered the completed HDR files to my client and they're happy with everything.

▲ RATING THE FILE FOR EASY SELECTION. As soon as each HDR file is rendered, I rate it with three stars to make it easy to select later. Then I move onto the next set of source images to create the next HDR image. (The reason I use three stars instead of just one is to make the later process of selecting and erasing the source files easier.)

▶ RATING FILTER. Once I have the source images processed, it's time to select all the HDRs by using the rating filter. This consolidates them all for placement into a collection.

▼ CREATE A COLLECTION. As you can see in the image below, I create a collection of all the HDRs, named with the property address and organized under the Collection Set called "Real Estate." This method has worked well for me, but you can certainly organize your files any way that works best for you. I like using collections for organizing because they make it easy to arrange the images prior to export. You cannot always shoot your homes in the sequence you'd like, but you should always try to present your images to the client (and their customers) in a sequence that gives the best sense of the property's layout. Both Windows and Mac platforms sort files by their file names and/or capture time, so you're going to be stuck with that if you don't use collections.

▲ **COLOR TEMPERATURE.** Once I have the HDRs in a collection, the final processing begins. The first thing I do is color temperature correction. This is done by selecting the Eyedropper tool in the Basic panel of the Develop module. I then click on a spot in the image that I know is either white or a neutral gray/black in the actual location. For some reason, I could not get my screen capture tools to show the Eyedrop-per, so I've placed a red cross at the spot I sampled in this image. The color sample box that you see to the lower left of the cross will show you what you have selected with the Eyedropper. Sometimes you'll have to play around with the Eyedropper by selecting several different areas in the image before you get an overall color balance you like. This can often be a matter of style or personal taste.

▼ **MIXED LIGHTING.** Because there are often several competing light sources in any given location (incandescent lights, fluorescents, and sunlight at varying strengths), you'll have to settle on one overall look, as shown in the image below. Then you can continue to fine-tune your color corrections by using other methods.

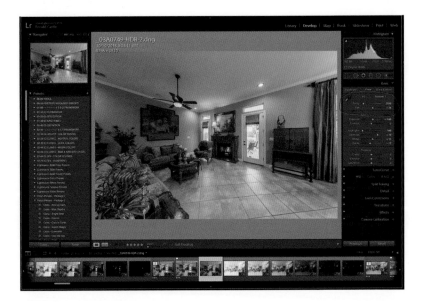

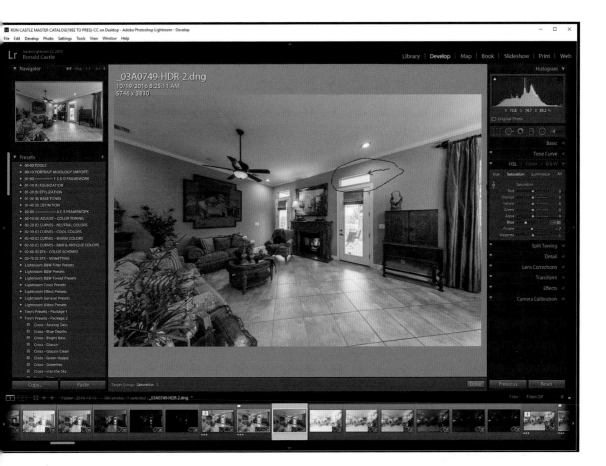

▲ **SUNLIT AREAS.** In the screenshot at the bottom of the facing page, you can see the blue hues (created by the sunlight) near the windows. This can usually be toned down or completely eliminated by reducing the blue saturation in the HSL (Hue, Saturation, Light) panel as shown in the screenshot above.

You can either use the sliders directly or you can use the button (shown circled in the upper left of the panel) to select a spot in the image that you want to desaturate appropriately. Using the button yields a more accurate correction because there are often small elements of other colors involved in a color cast. You can see this where I've circled the Blue and Purple slider settings,

which were a result of selecting and dragging down on the saturation button near the area above the window (shown by the red circle and arrow).

Targeted color corrections can also be made to parts of the images using the Adjustment brush, the Graduated filter or the Radial filter. Each of these tools allow "painting on" areas of warm or cool color as well as tints of green or magenta. Often, when an image is corrected to the room's predominant incandescent color, the outdoor scene showing through the windows is going to be overly blue (cool). By using the Adjustment brush set to a warm temperature you can paint over the windows to make the outdoor scene look more natural.

◄ **SELF-GUIDED UPRIGHT TOOL.** I mentioned earlier the one great new feature available in the newest update of Lightroom CC, is the Self-Guided Upright tool. This is found in the new Transform panel. By clicking inside the circle with the cross-hatched lines (circled in red) you'll be able to place up to two vertical lines and two horizontal lines on the image in order to correct any perspective distortions.

▼ **PLACING THE FIRST LINE** *(top left, below).* This screen shot shows the initial horizontal line (highlighted in yellow and circled in red) placed at the bottom of the bed.

▼ **PLACING ADDITIONAL LINES** *(bottom left, below).* Nothing will be corrected until the second line (horizontal or vertical) is placed on the image. As you can see, several lines have been placed in this screen shot. Not only did this action level the ceiling and align it with the bottom of the bed, but placing the two vertical lines lined up the back wall perfectly square to the camera!

If you had only added one vertical to the two horizontals, it would have straightened everything horizontally and vertically, but the back wall would have been slightly off parallel with the front plane of the image. When shooting into the corner of a room at a pronounced angle, you only want to add two vertical lines and no horizontals at all. After you play with this feature, you'll get the hang of it quickly. It's light years ahead of what was available in the previous "upright" window of the Lens Correction panel.

► **ADD A LITTLE PUNCH** *(facing page, top).* After I've finished making all my exposure adjustments, color corrections, perspective adjustments, and crops, I'm ready to make

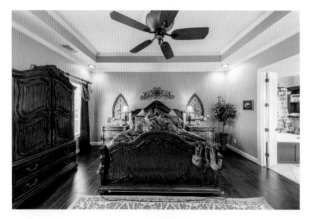

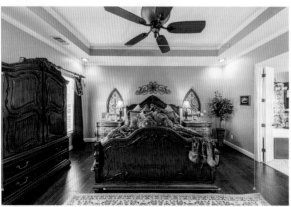

ON1 PHOTO 10. For day-to-day adjustments to client work, I stick with Lightroom adjustments for everything, but for my portfolio images and some selected client work, I take my final processing into a program called ON1 Photo 10. I love their layered interface and the many color and dynamic contrast options they offer. However, using Lightroom will get you very close to the same results, in most cases. Since your images are rarely seen outside the Multiple Listing Service online environment, the differences between Lightroom and ON1 processing will probably be indistinguishable.

some final tweaks to add a little "punch." The items highlighted in yellow in the screen shot are the ones I typically adjust at the end of the process. The settings you see are the ones that come from the normal import settings and the HDR auto-toning process. The sharpening amount of 25 is referred to as RAW Sharpening and is one of the default settings applied by Lightroom to all files upon import. The other settings are always the same when you select Auto Toning in the HDR dialog. The only number that will vary from image to image is the Exposure.

▼ TYPICAL SETTINGS. This screenshot represents my typical settings for the final client-delivered image. The changes are

shown in highlighted yellow. To brighten the overall image, I raise the contrast level to about 25–40 points, and then I start slowly raising the exposure level in $\frac{1}{10}$-stop increments until the image "pops" to my eye without looking overexposed and washed out. It usually takes about a $\frac{1}{3}$-stop increase to do this. Next, I raise the Clarity to about 17 to give the image a little extra dynamic contrast. I raise the Vibrance to about 10 to gently increase the color saturation. The Vibrance setting is very much a matter of personal taste and style and it can also depend on the color intensity already present in the image. In some cases, I actually reduce the Vibrance or Saturation to make the image match the look of others in the set. I use the same Sharpening and Noise Reduction settings for most of my images since I always use the same ISO setting (400). One thing I'll also add at the end is a small amount of post-crop vignette, darkening the edges slightly. I do this individually to each image because one size does not always fit all in this case. It's easy to overdo it with a vignette.

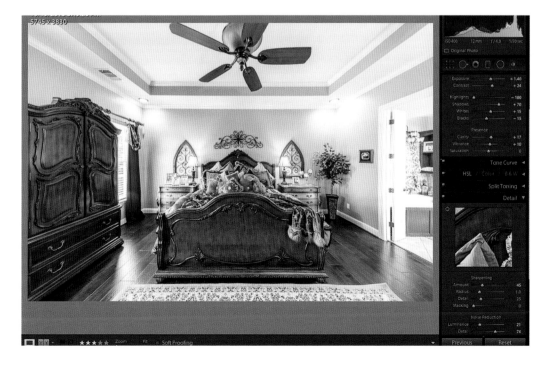

▲ A SIMPLE TRICK. Lastly, I thought I'd show you a trick I came up with one day while trying to salvage a dull-looking sky. One thing that most realtors like to see in their exterior shots of the home is nice blue sky! Obviously, this isn't always possible—so I experimented one day with the adjustment brush set to a very "cool/blue" setting and painted some areas of the cloudy sky with it. In this screen shot, you can see one stroke applied to a small area of the sky.

▶ BLUE SKIES *(facing page).* Here, you can see the completed version that I delivered to the client. The sky in the screen shot at the bottom of page 33 was also created with this technique. It doesn't always work well, but (if done correctly) it can often rescue dull exterior shots of the house. I've found that just a hint of blue here and there does the best job of brightening up the image, and this quick technique beats the time it takes to do a complete sky swap in Photoshop!

"One thing that most realtors like to see in their exterior shots of the home is nice blue sky!"

"I hope you now have a sense of how I achieve what I do …"

FINAL THOUGHTS. I hope this gives you an idea of how to post-process your HDR images in Lightroom CC. I know it hasn't been a complete tutorial, but I hope you now have a sense of how I achieve what I do—and can keep these techniques in mind as you look through the sample images presented in the rest of this book. There are numerous online video resources available that can do a much more thorough job of explaining how to use Lightroom, as well as some unique techniques used to process real estate images. My favorite website is Lynda.com, and doing searches on YouTube can also yield some very good how-to videos on real estate photography!

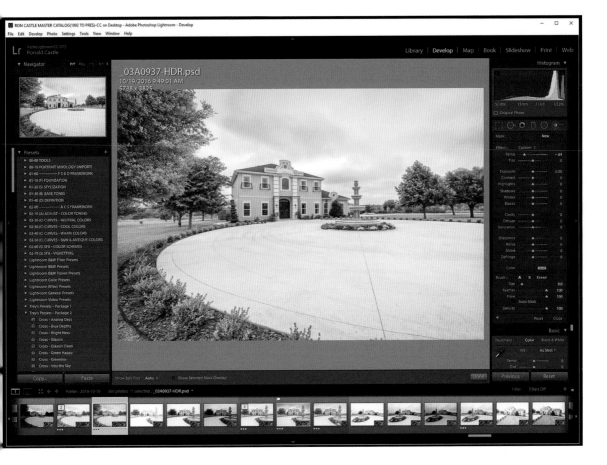

5. SAMPLE HOME 1

The rest of this book will consist of a series of "case studies" from homes I've shot over the past couple of years. They're images that were actually delivered to a client, but they don't necessarily represent all of the files I delivered for each home. It would have been easy to cherry pick the very best of my work, but I don't know if that would be as effective as showing you some examples of what *not* to do as well. These images will not always be perfect—in fact, some were chosen because they are *not*. I'll be pointing out the flaws and the good points of each image to give you the best perspective on what good and bad real estate images look like. I'll point out aspects of composition that work and some that do not. I'll also use these images to make points that aren't easily made without good examples. Some things we haven't talked about yet such as "staging" (prepping the home before photographing) will be discussed. We will also go over the sequencing of the shoot, what you must shoot in a residence, and what's best to leave out. Exceptions to these

"rules" will be seen throughout the images, so you'll get better at making your own judgments as you go along.

Since most images are HDR files made from multiple source images, it won't be possible to give you exposure settings like you see in many photo books. (*Note:* Some exterior shots and *all* of the drone shots were single exposures, so those settings will be included.) Hopefully, the samples will help you appreciate just how powerful a tool the Lightroom HDR exposure fusion process is—and what a great variety of difficult lighting situations it can tackle. This should give you the confidence to take on whatever situation you're likely to encounter as a real estate photographer.

▼ **OKAY (BUT NOT OPTIMAL).** Probably the most important shot you'll take of a residence is the front exterior, because that's the shot the realtor is going to use for the listing thumbnail. If it doesn't have impact and get a buyer's attention, it's likely the listing will be ignored. I like to give my

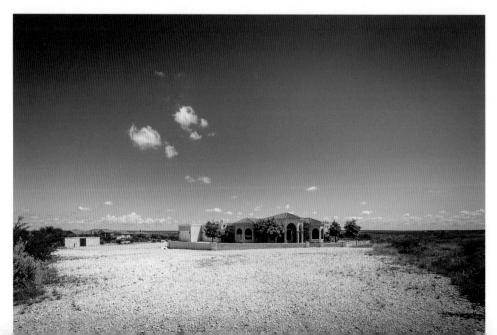

realtors at least three different angles/options for this shot. The facing page image shows how big the lot is, but the home is so small in the picture that it lacks impact. It's fine to include this with the other listing images, but it would be a poor choice for the listing cover. *Exposure settings: ISO 400, f/8.0, and ¹⁄₅₀₀ second.*

▶ **A BETTER CHOICE** *(top right).* This image is better and it still gives some sense of the scale of the whole property. It has more impact than the previous shot, but I still doubt that it would be enough to notice in a small thumbnail. To point out another important detail, I actually went back to reshoot the front of this house because when I finished the interior shots during the late morning appointment, the sun was not fully shining on the front of the building. I tried to salvage that first session by using HDR, but the angle of the sun caused enough flare that the exterior images just did not have the detail and good contrast these full-sun shots do. *Exposure settings: ISO 400, f/8.0, and ¹⁄₅₀₀ second*

▼ **THE REALTOR'S PICK.** This shot of the home includes enough of the lot and front entryway that it does have plenty of impact. This is the shot that the realtor chose for the primary listing image. Notice, also, that the straight-on composition adds strength to the image since the porch is so dominant in the center. *Exposure settings: ISO 400, f/8.0, and ¹⁄₈₀₀ second*

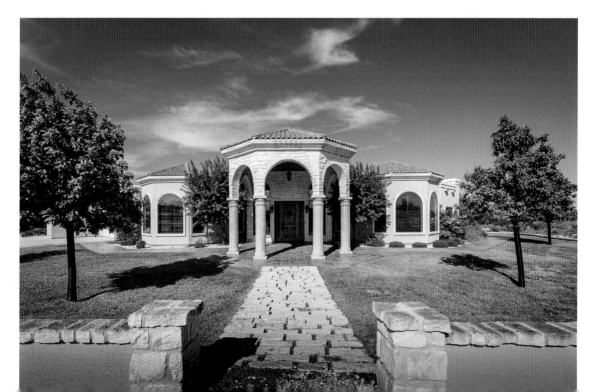

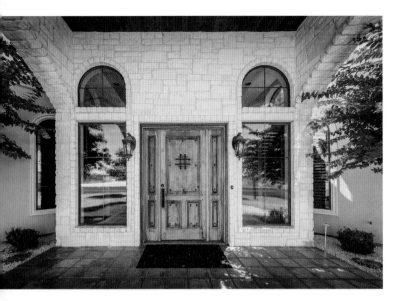

▼ ARCHED WINDOWS (below). This is a side angle of the exterior front. I set this composition to show off the beautiful arched window by placing it near the imaginary one-third vertical line (according to the rule of thirds) and also by adjusting the camera angle to show the slope of the porch roof as a leading line. *Exposure settings: ISO 400, f/8.0, and ¹⁄₁₀₀₀ second.*

► LEADING LINES (facing page, top). This view of the back patio area was taken from the right side of the home and uses the leading lines of the porch steps and the roof line to draw the viewer's eye to the kitchen dining area windows. HDR capture worked fine for this image since there was minimal wind and very little vegetation. If HDR had not been

▲ DOOR DETAIL. I scored brownie points with the realtor by taking this detail shot of the door. It was custom-made and was one of many features of this home that spoke to its build quality. Don't overlook an opportunity to take detail shots when they can communicate the uniqueness of that home.

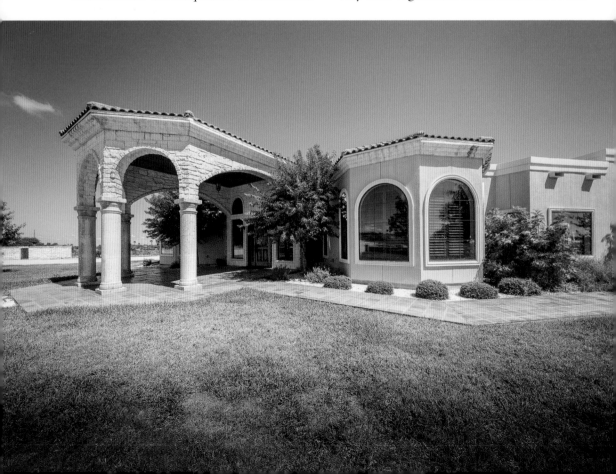

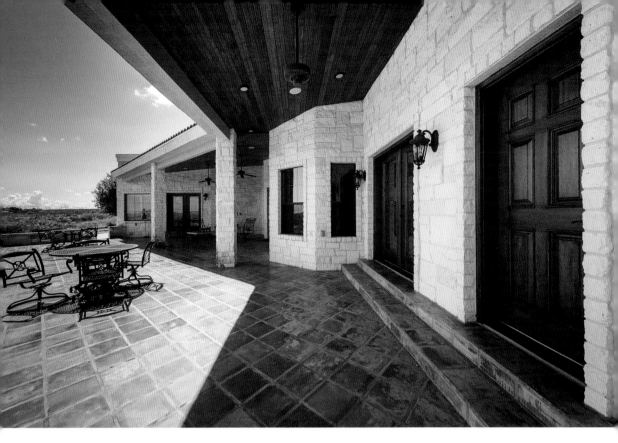

used for this image, the bright area of the patio would have been completely blown out with a good exposure of the shaded area (or vice versa). As it is, both areas are rendered with great exposures and detail throughout.

▼ **ALTERNATE VIEW**. This shot was taken from the other side, and this composition also uses leading lines from the floor tiles and ceiling boards to take the viewer's eye to the one-third line on the right side. The interesting angles of the various wall surfaces make this a very pleasing view.

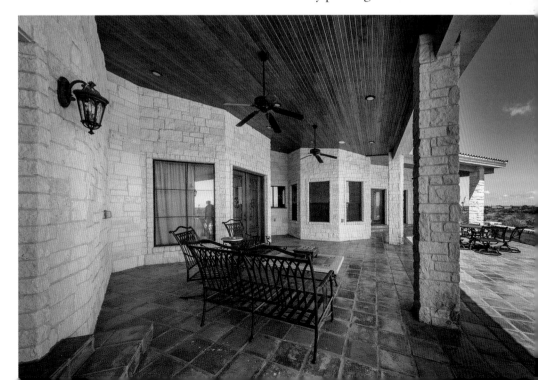

they had been off even a little bit, this would have been an awkward composition. Situations like this are perfect examples of how the Guided Upright tool can be used to fine tune the composition. It's very difficult to get this perfect in-camera, but the Upright tool makes it easy to do.

▲ **STRONG SYMMETRY.** This angle of view, looking straight out toward the backyard area, is strong because of its symmetry. The space between the columns is centered, and you'll notice that the horizon line, the top line of the porch wall and the horizontal lines of the tiles are all roughly parallel. If

▼ **THE OPPOSITE VIEW.**

This is the same type of composition as in the previous image—but taken from the opposite view. Once again, the Guided Upright tool makes it easier to get this kind of symmetry. This angle also gives the prospective buyer a good idea of the size and functionality of the patio area.

► THE SURROUNDING AREA. This view shows more of the home taken from the same side as the image at the top of page 43. By including more of the surrounding area you get a more complete view of the home's back patio area.

▼ DRONE VIEW 1. This is the type of home that can benefit greatly from aerial views that only a drone can provide. It not only shows all of the home, but also the surrounding area and the nearby lake. The layout of the front driveway and parking area is also shown, which can be a big selling point for a buyer who plans on hosting a lot of social events. The leading lines of the driveway point to the home, which is placed on the one-third line of the composition. The horizon line is also set level and parallel with the front porch wall segment. This was done purposely by positioning the drone appropriately and then fine-tuning it with the Guided Upright tool. *Exposure settings: ISO 100, f/2.8, and 1/2000 second. (Drone shots were made in automatic mode.)*

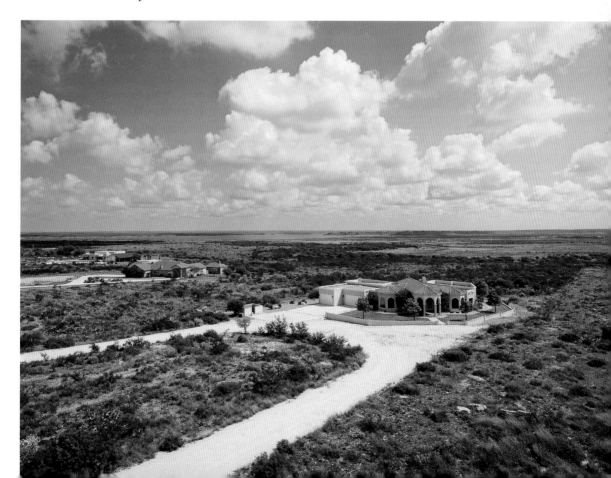

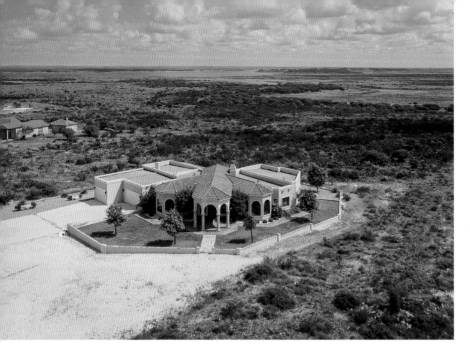

◀ **DRONE VIEW 2.** The composition of this close-up view of the front area is once again strengthened by making sure that the front wall was parallel with the horizon. *Exposure settings: ISO 100, f/2.8, and ¹⁄₂₀₀₀ second.*

▼ **DRONE VIEW 3.** This higher-altitude shot was intended to take in a maximum view of the surrounding area and to also show more of the overall layout of the property. This helps the prospective buyer see just how big the lot is and how private this location is. *Exposure settings: ISO 100, f/2.8, and ¹⁄₁₄₀₀ second.*

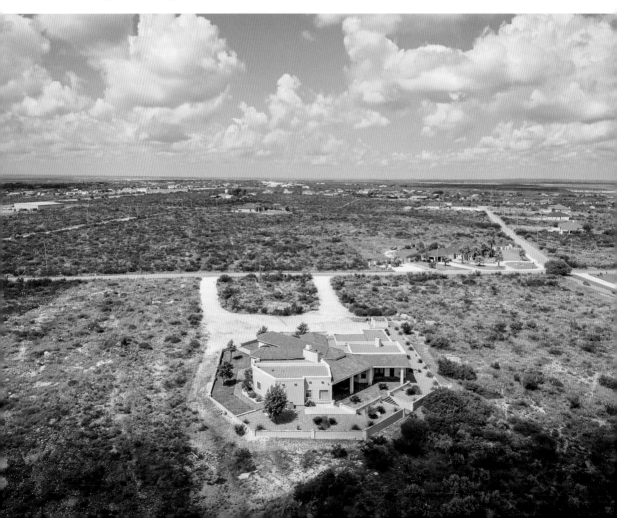

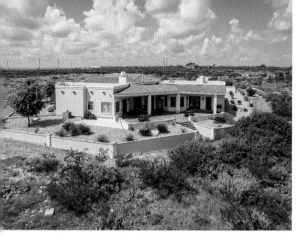

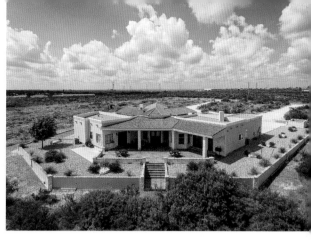

▲ **DRONE VIEW 4: NEEDS IMPROVEMENT.**
Compare this view with the composition in
the next image. This angle of view creates
some confusing angles with the wall and build-
ing surfaces. It does not add much to what we
know about this property. *Exposure settings:
ISO 100, f/2.8, and ¹⁄₁₅₀₀ second.*

▲ **DRONE VIEW 5: BETTER.** This close-up and
symmetrical view grabs attention and provides
the information a buyer needs to know about
this side of the house. The horizon line and
the wall lines are parallel to each other, result-
ing in a pleasing composition. The leading
lines of the driveway strengthen the shot. *Ex-
posure settings: ISO 100, f/2.8, and ¹⁄₁₆₀₀ second.*

▼ **DRONE VIEW 6.** I generally provide five to six shots with my drone package, so this rounds
out a final trip around the home with a unique view. No other views of this property show the ar-
rangement of the two-car garage next to the porch and the boat garage on the outside. You can
see how much longer it is than the car garage, but it's only possible to see this effectively from
the elevated view. It also shows the propane gas tank that services the home; from a ground view,
this is hidden by the walls surrounding it. *Exposure settings: ISO 100, f/2.8, and ¹⁄₁₈₀₀ second.*

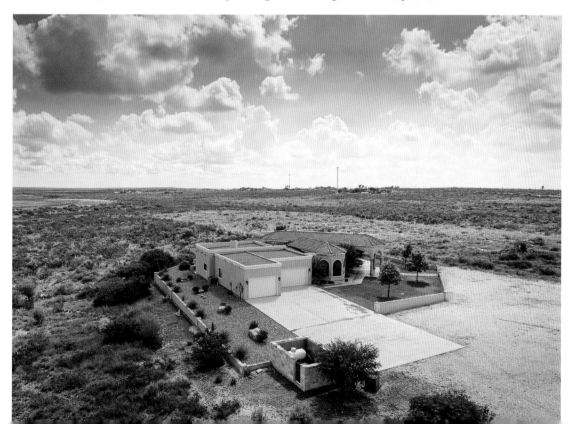

▲ **WATCH THE DETAILS.** After presenting the buyer with exterior shots, we move inside. This shot is taken from right inside the front door, looking into the living room. It's a very strong symmetrical, one-point perspective composition, but there are a couple of things I wish I'd done to improve it. There are at least two distractions in the foreground that could have easily been removed (if they'd been noticed at the time). One is the flower sticking into the composition from the lower right corner, and the other is the thin, vertical black rectangle protruding past the front left column. The flower pot could have been moved out of the way, and the rectangle could have been eliminated from the scene by pulling back just slightly with the camera. As you get more experience, you'll get better at seeing these kind of things, but it seems like something always manages to sneak by at least once a shoot.

▶ **SHOW THE FLOW** *(facing page, top)*. When I'm shooting a home with this much space and so many beautiful angles, I always try to incorporate as many rooms as possible into a shot. This can give the buyer a better idea of how the rooms flow together in a home. To accomplish this, it helps to keep at least one recognizable feature from one shot in the following shot to help anchor the viewer. In this second shot, I moved to the left side of the living room wall and took an angle toward the right side. The common element in this shot with the previous is the patio double door.

▶ **ANOTHER ANGLE** *(facing page, bottom)*. This was shot from the same spot as the previous image. I rotated another 35–40 degrees and took another view incorporating the front entryway and the bedroom you see in the distance. Notice that the Western painting on the far left is the common element with the previous shot.

▲ ANOTHER ANGLE. This shot is taken from the living room patio doors looking back toward the front entryway. It's not as obvious this time, but the painting is still a common element seen over the fireplace on the left.

▼ STAGING. This shot shows the entire wall with the painting and the rest of the living room in much better detail. Notice the books on the coffee table. We haven't talked about "staging" up to now, so I'll use this example to start the discussion. Staging is a common term used in the architectural/real estate world that simply means prepping a home or building to be photographed. This can mean anything from placing furniture and decorations in an unoccupied home or building, to simply going through a home and straightening things up to look good for the camera. As we go along, I'll be pointing out examples of things that should be done to "properly" stage a home before your arrival. In regard to the books, I think having no books on the coffee table, or at least removing the stack on the right, would have looked better for this shot. This is a judgment call here, but when in doubt (and it's practical) removing any clutter from furniture surfaces is always a safer bet. They can be a distraction, and have the potential to draw attention away from more important parts of the scene.

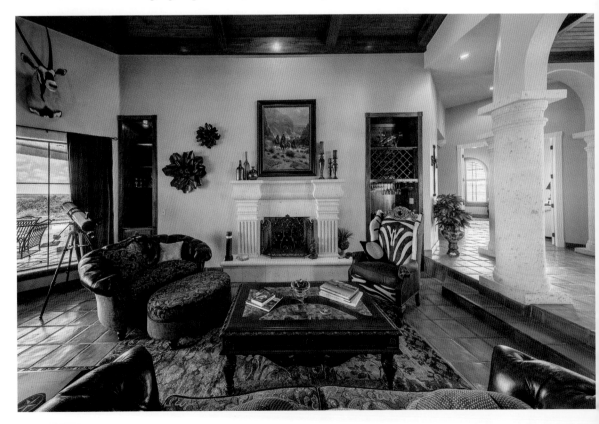

▶ **STAGING: THROW RUGS 1.** This guest bedroom is the one shown from a distance in the image at the bottom of page 49. Continuing the staging discussion, I want to point out the brown throw rug near the windows. You'll notice that it's not straight with the wall and is hurting the composition. This is something else I did not notice until I was looking at the images after the shoot. I encourage you to look at all throw rugs in a room before you start photographing. If you can't make them work for the composition, remove them altogether. This is especially true in small bathrooms and kitchens. The cowhide in the foreground is fine because it's an irregular shape to begin with. It also adds interest to the image. Another consideration is the floor itself. This beautiful rustic tile should be a great selling feature for the home. The more of it you can show, the better.

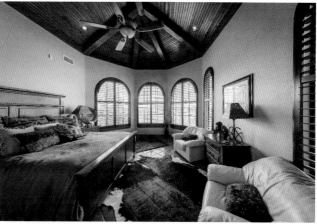

▼ **STAGING: THROW RUGS 2.** This shot is taken from the window side of the bedroom pointing back out to the entry area and living room. You'll notice the mirror on the living room wall that connects it from other images. Once again to make the point even stronger with the rug. Look how distracting it is not only by being out of alignment, but also by hiding the beautiful tile floor in this part of the image.

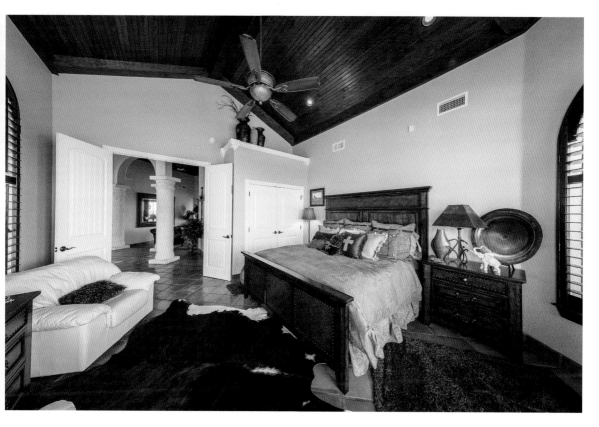

▼ STAGING AND COMPOSITION
IMPROVEMENTS. This is another small guest room. I want to point out a couple of things here concerning staging. First, I want to distinguish between staging, which should be done before you arrive at the home, and minor adjustments you can/should make while setting up a shot. Removing clutter, straightening up furniture, making beds and generally cleaning up are

▲ **DINING ROOM.** This is the formal dining room, located right off the entryway. It was shot as a one-point perspective to highlight the beautiful ceiling and window arrangement. This image also could probably benefit from removing the distracting pot in the lower-left corner and the crosses on the wall by cropping into about the middle of the window (vertically).

the home owner/agent's responsibilities. Rather than give you a long list of things that should be done for each room, I'll be pointing out specific examples as we go along to hopefully make the point a little stronger. Even though it's not your job to stage the home, you should always be mindful of minor things that you can do to improve a shot by moving things around in a room depending on the angles you choose

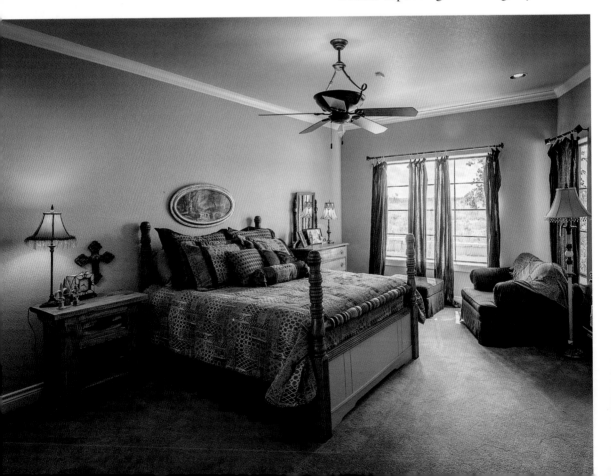

to shoot. This can mean changing the placement of chairs, moving things around on table tops, etc. In this scene, there a few things I could have done to improve things. First, notice the lamp's electrical cord dangling over the side of the left night stand. That should have been hidden by simply moving it around to the rear. Also, on that same night stand, the two ceramic pieces would look better if they were placed to the right of the clock, balancing out the layout. It's a small thing, but it would have helped the composition. The biggest item that (in hindsight) should have been dealt with is the foot rest that's located in front of the window. I didn't think a lot about it then, but after looking

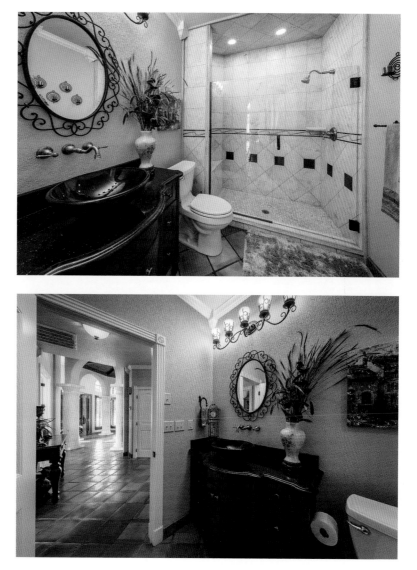

at the finished composition, I realize that it should have been moved out of the picture completely. Moving it closer to the bed and slightly to the left would have totally hidden it from this camera angle.

▲ **BATHROOM, VIEW 1** *(top).* This is a hall bathroom located next to the guest room. Not to beat a dead horse, but can we say "throw rug" again? This was a home I shot earlier in my career, so I like to think I've gotten better since. You'll notice how clean the bathroom is and there aren't any tooth-

brushes or other clutter around the sink. Also, there's no soap or shampoo in the shower. One other thing to bring up here is that you want to have the toilet seat *down* in all bathrooms.

▲ **BATHROOM, VIEW 2** *(bottom).* This is another attempt to give the home buyer a little perspective by shooting out from the bathroom back toward the entryway. This gives them a clear feel for where this room is located in the home.

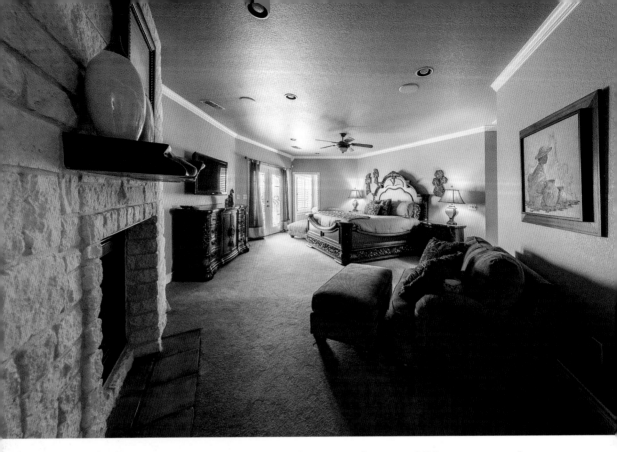

▲ A LONG SHOT. Moving down the hallway from the bathroom is the entryway to the master suite. This is a deliberately long shot, so you can see the fireplace and size of this magnificent room. To make another staging point here, always turn off ceiling fans. If you don't, your photos will have what looks like "flying saucers" hovering in the rooms! It's so common for agents or home owners to go through the house before you shoot, turning on all the lights and the ceiling fans right along with them. Try to catch them early because it's sometimes very time-consuming waiting for the fans to stop (especially if you can't reach them from the ground).

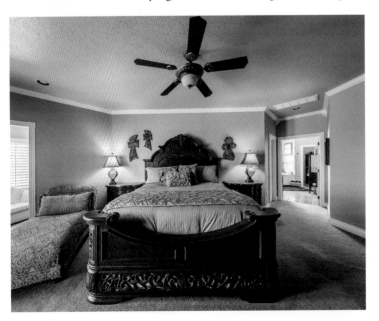

◀ A CLOSE SHOT. This is a close shot of the bed that's been purposely set up to be square to the camera while revealing two other rooms nearby. There's a small office entry to the left and the master bath seen farther away and to the right. It's not obvious, but there's a door to a huge closet on the left side of the entry hall to the bathroom.

▶ **HOME OFFICE.**
This is the office space from the left side which can be recognized because of the wall color, and the white couch visible through the doorway in the previous image. It's certainly not obvious, but it is there if you're paying attention!

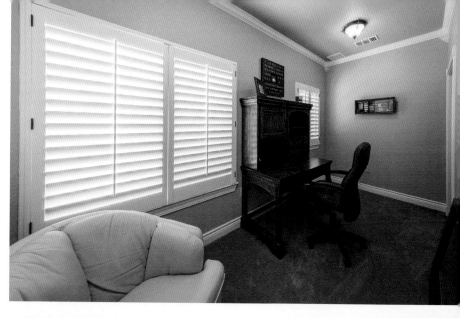

▶ **IMPRESSIVE CLOSET.** This is what I meant by "closet." You don't see many like this one, but when you do, you need to include it in your shot list. However, in most cases, I do *not* recommend shooting closets. This one is an exception— and it still took a little extra effort on my part to straighten up and make it presentable for this photo.

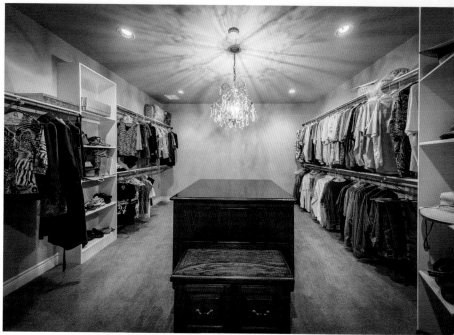

BUILD THE INTRIGUE. My philosophy on what to include and not include in my shot list can be summed up by one comparison. When you look at a movie trailer, do they show you everything? Of course not. They're trying to build up enough interest and excitement to get you into the theater to watch it. Your job as a real estate photographer is to do the same thing for a potential buyer. You want to get them intrigued enough with what you show them to get them off the couch and into the home for a personal tour with the agent! Showing them every closet, laundry room and garage will not do that. You need to make that point early and often with all your agents, and if you meet the home owner before the shoot, you need to do the same with them. If you get them to buy into that idea ahead of time, the chances of being called back because you didn't shoot the tiny hallway bathroom is greatly reduced.

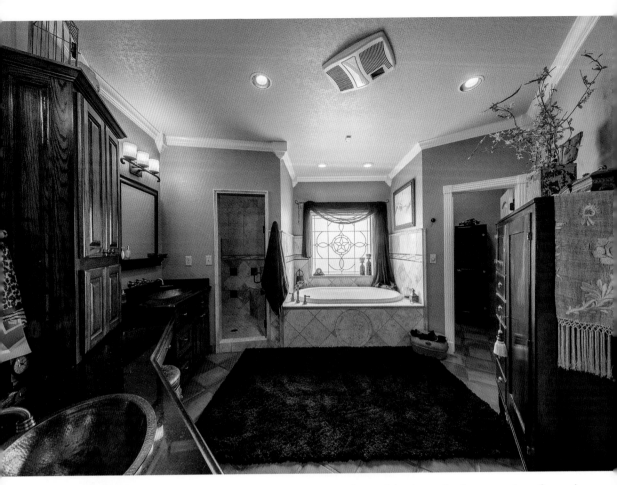

▲ **BATHROOM OVERVIEW.** This is the overview shot of the huge bathroom taken from the doorway to the bedroom. It was purposely lined up squarely with the far wall with the tub, and in this view the large rug works nicely with this composition.

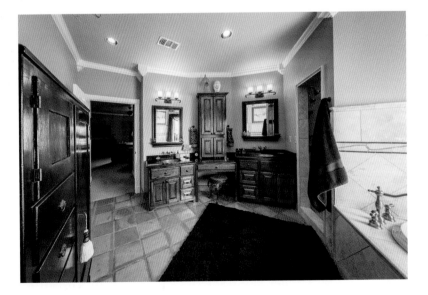

◄ **THROW RUG PROBLEM.** This is the angle taken from the back of the bathroom toward the bedroom doorway. As you can see, the rug clearly does *not* help this composition. I should have rolled it up and taken it out of the scene altogether and the floor tile would have made a much nicer foreground.

▶ **VANITY AREA CLOSE-UP.** In this detail shot of the vanity area, there was a small corner of the rug sticking into the composition. It was disturbing enough to me at the time that I rolled it back enough to take it out of the image. Why didn't I see that for the previous shot?

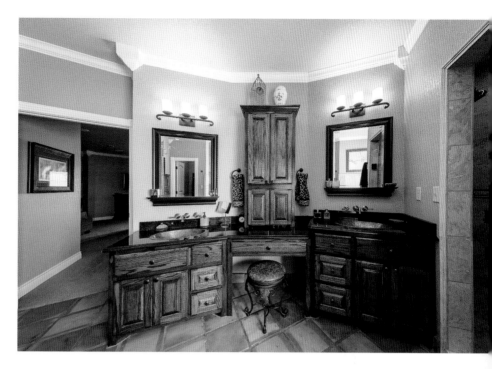

▼ **UNUSUALLY PHOTOGENIC LAUNDRY ROOM.** Here's another example of what I normally *don't* shoot. In this case, however, the laundry room is clearly photogenic and an obvious selling feature. I did have to move some detergent bottles and other items out of the way before I took the shot, however.

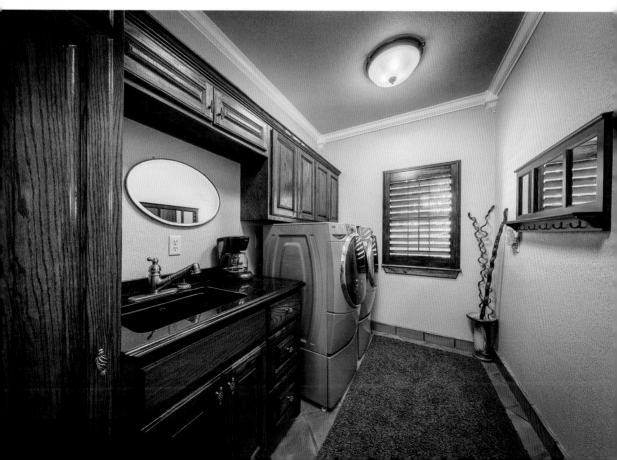

▼ **ESTABLISHING SHOT** *(top)*. This is the entrance to the kitchen, and is what I sometimes consider an "establishing" shot. This is a movie-making term that refers to a wide shot of a scene to reveal the overall setting before moving in to the main location. The height of the camera was brought up about level with the bottoms of the cabinets. This allows a more complete view of the entire room and a good look at all the counter surfaces. The home owner has done a great job of staging this area by cleaning off the clutter from counter tops.

There are just enough things (like the knife block, the pottery, and the coffee maker) left on the counter top to give a natural feel to the kitchen as well as some interest to the composition.

▼ **CONTINUITY, APPLIANCES, DETAILS** *(bottom)*. Now we move into the kitchen, keeping the movable island in the foreground so the buyer remains oriented with the entryway. I've included as many appliances as possible in this one shot, since they are strong selling features of this kitchen. Can you spot the one little detail we missed during the staging? Yep, the bright pink magnet on the refrigerator! Honestly I didn't see it until I started writing this caption, and it could have been easily removed with the cloning tool in Lightroom! As you get some experience, you'll noticed that refrigerator magnets are often missed by the homeowner, so you'll usually end up taking care of that yourself.

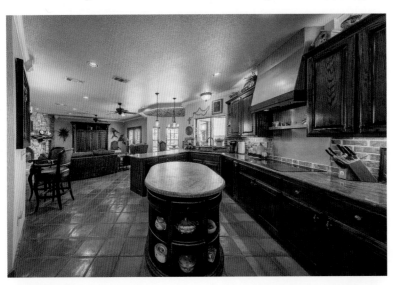

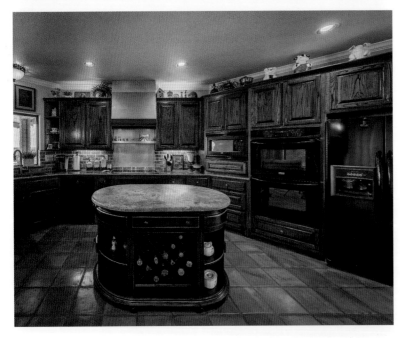

"Can you spot the one little detail we missed during the staging? Yep, the bright pink magnet on the refrigerator!"

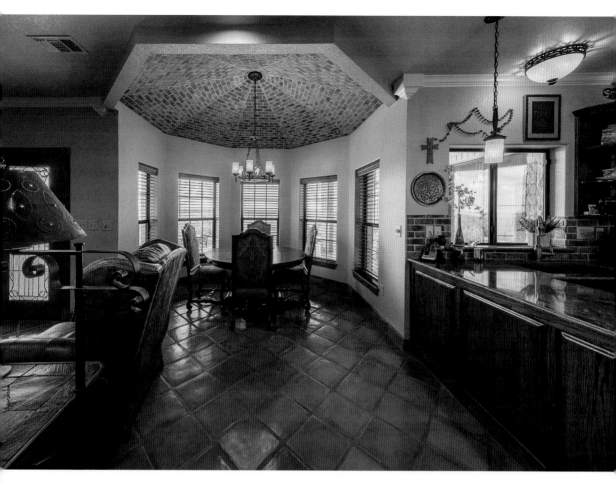

▲ **BREAKFAST ALCOVE.** Moving past the cabinets and sink area, I've taken this straight-on, one-point perspective shot of the breakfast alcove. Notice I've lined up the shot so the top of the recessed ceiling is perfectly parallel with the top of the frame meaning the plane of my camera lens is perfectly aligned with the far wall.

▶ **DEN.** This shot shows the den from the breakfast area and includes the other area of interest in the room, which is the small bar on the far left. The rug in front of the chairs is not a distraction in this shot, but it probably should have been removed since the next image (page 60, top) clearly does not benefit from its presence. The tile is much more photogenic.

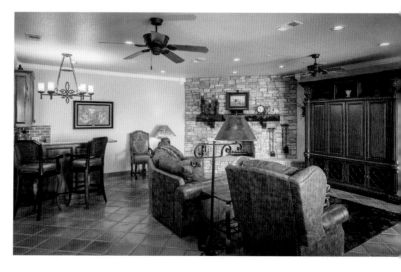

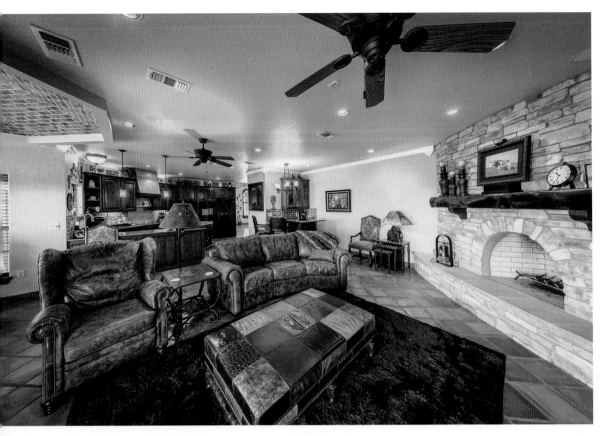

▲ **WIDE-ANGLE LENS DISTORTION.** This angle shows one of the drawbacks to using such a wide-angle lens as the 11mm. In the previous shot, you can see the fireplace in its natural proportions. When you see it here, the stretching and distortion is obvious and distracting. The way to fix this without changing lenses would be to move farther away from it and change the shooting angle slightly inward. I don't think that would fix the distortion completely, but it would improve the shot.

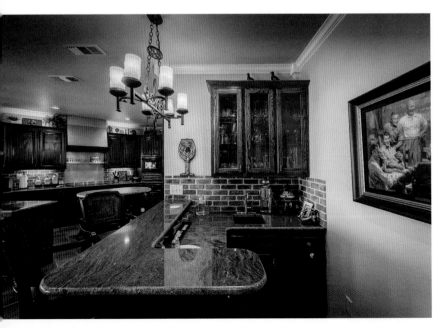

◄ **A STAGING PROBLEM.** This is a close-up of the bar area, and it points out another example of poor staging. The items you can see sticking out from under the bar top should have either been hidden completely or some items brought to the top and arranged in an interesting way.

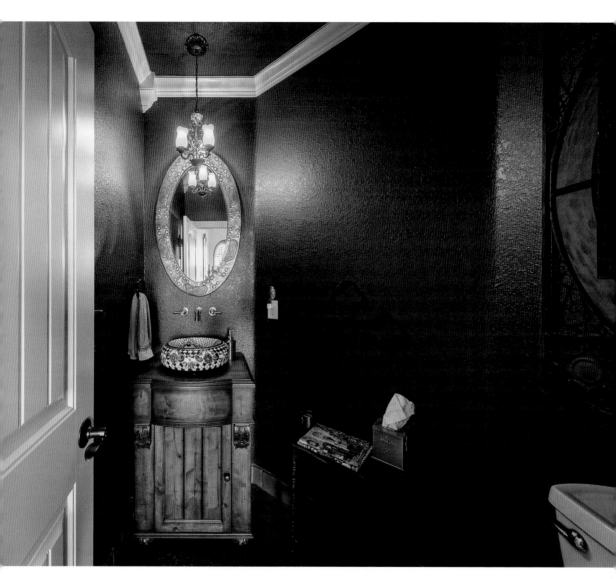

> "As you can see, the colors, fixtures and decorations are quite photogenic."

▲ **THE CUSTOMER IS ALWAYS RIGHT.** This was the last shot for this home, and normally I wouldn't bother with a small half bath like this. However, as you can see, the colors, fixtures and decorations are quite photogenic. Oh, and also the agent directed me to shoot it. The customer is always right!

6. SAMPLE HOME 2

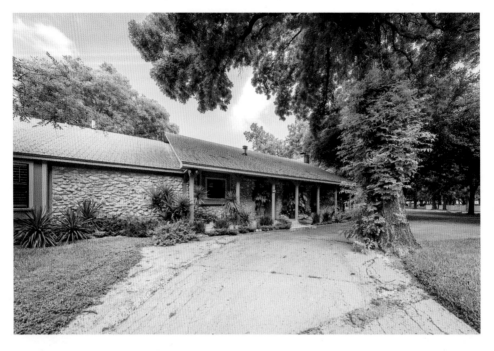

▲ A TROUBLESOME TREE. Getting a close, impactful exterior front shot of this home was a real challenge. A huge tree is located right in front of the entryway, obstructing any clear view of the door to the house. The other challenge was the fact that there were extremes of light and shadow stemming from the deep shade of the tree and the bright sunshine. This meant the only way to get a good shot was through multiple exposures for HDR. Even though there wasn't a strong wind blowing, there was enough movement in the tree's branches to create some blurring of them in the final image. This was a necessary compromise. By selecting an angle to the side of the tree, it was possible to get most of the front of the house in the image—but it still doesn't give a good view of the front entrance.

► A BETTER ANGLE *(facing page, top).* This angle accomplishes two things. It gives the buyer a very good idea of the size of the lot and it also gets most of the home in the picture. Placing the foreground tree on one of the one-thirds points gave the image some much-needed punch for the listing thumbnail.

► WALKWAY CLOSE-UP *(facing page, bottom).* This close-up of the front walkway helps to complete the story of the front entry area. It provides more detail than was possible to convey with the first shot taken from the other side.

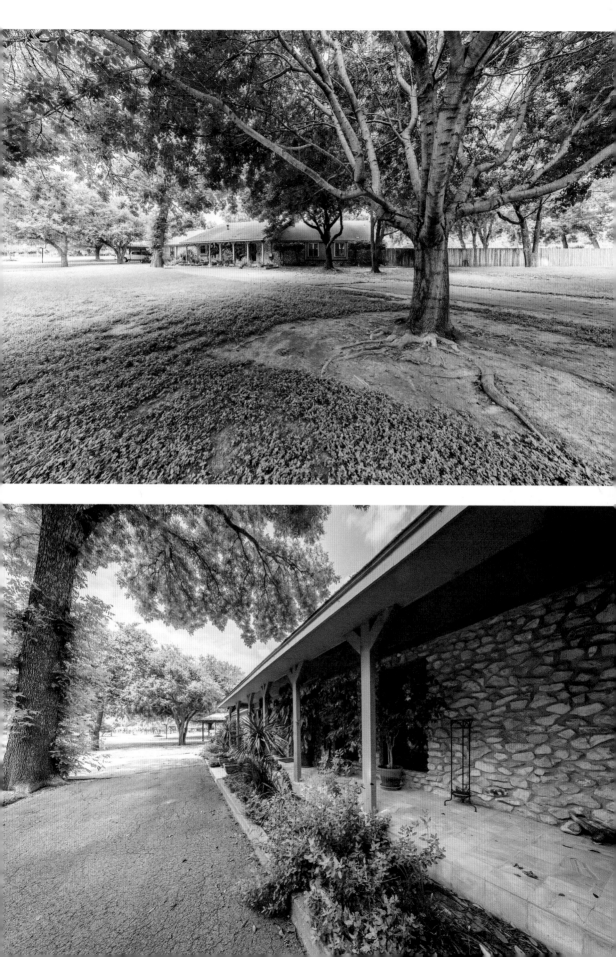

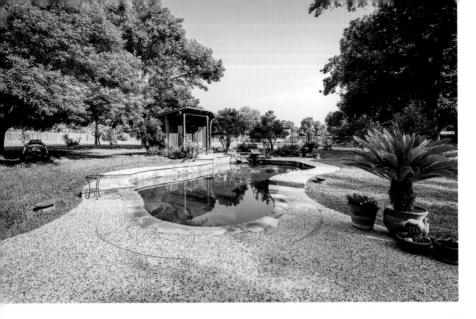

"The pool was the obvious focal point of the layout, so a close-up was necessary to show how unique it was."

▲ **A UNIQUE POOL AREA.** The backyard in this home covered more than an acre, so several camera angles were necessary to communicate this feature to potential buyers. The pool was the obvious focal point of the layout, so a close-up was necessary to show how unique it was. This angle shows the waterfall coming out of the hot tub area as well as a view of the changing room/shower structure. This shot would have looked better if the large toy car under the tree (left) had been moved out of the scene!

▼ **SHOW THE SCALE.** This angle better shows the scale of the pool. If you look carefully, you'll notice that the doors to the dressing shack were purposely left open to reveal the toilet and shower stall.

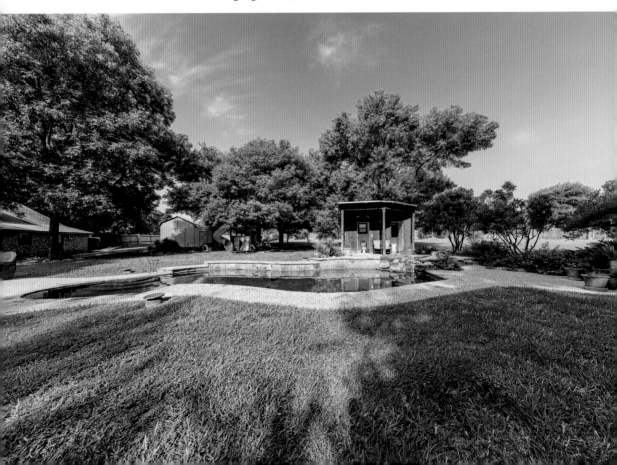

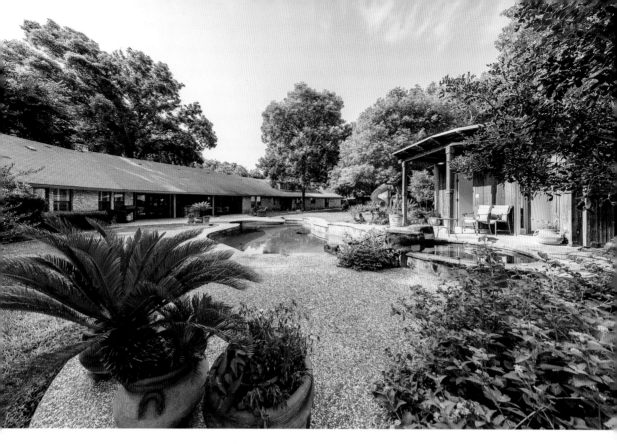

▲ ANOTHER ANGLE. Moving around to this angle shows the hot tub more clearly, and gives the viewer a good look at how the beautiful landscaping relates to the back of the home. The foreground bushes were intentionally included to show plants in more detail and make this a better composition.

this important feature. The placement of the home and pool is also shown in a spectacular way. This view shows a little of the surrounding neighborhood and the gorgeous landscaping, too. *Exposure settings: ISO 100, f/2.8, and $\frac{1}{1800}$ second.*

▶ DRONE SHOT. This home very much benefits from an aerial view to give buyers a better sense of the lot size. No ground-based angle could adequately show

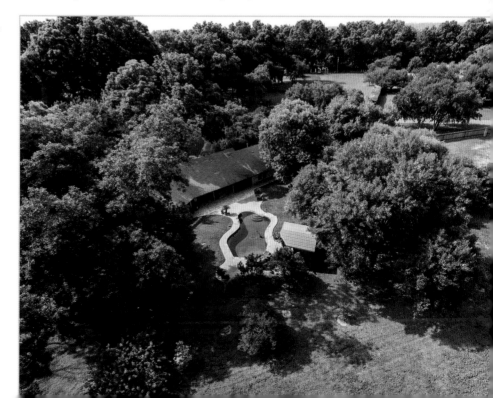

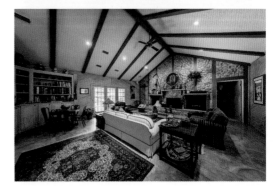

▶ **LIVING ROOM, VIEW 1** *(top)*. This angle shows the size of the room and its connection to the backyard and dining area. It was taken with an 11mm lens so there is some edge distortion. Cropping in to hide the object in the lower right corner would have improved this shot. Also, the two coasters on the foreground table should have been removed. Notice the family pictures on the table near the far wall. Generally, it's not a good idea to have family pictures showing in the listing photos. In this case, they're far enough away to be unrecognizable.

▶ **LIVING ROOM, VIEW 2** *(bottom)*. This is from the opposite side of the living room. The 11mm lens is not our friend on the right side of the image. The stretch of the door is very distracting. It should have been cropped in to show half of the its width. By dragging the crop down at the same aspect ratio from the upper-right corner, some of the ceiling could have been eliminated along with the air conditioning vent on the far left top. Cropping this way would still show the cabinets and shelves on the left, which are a nice feature in this room.

▼ **LIVING ROOM, VIEW 3.** This one-point perspective of the room is probably the best view. The camera's lens is aligned with the far wall and that wall is centered in the frame. There is some distortion on the doors to the left, but it's not as distracting as in the previous shot. If you did want to minimize the distorted view, you could experiment with a 4x5 crop and move in on those side doors without losing any of the foreground and the nice ceiling.

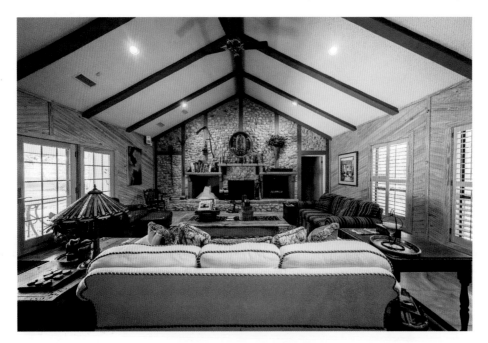

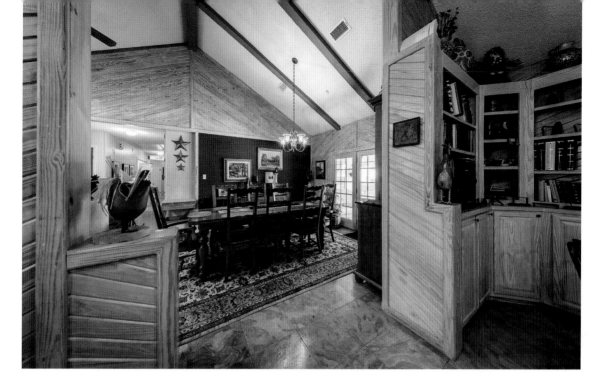

▲ **DINING ROOM.** Including part of the living room cabinets in the right side of this shot gives the viewer a good feel for how the dining room and kitchen areas relate to it. I was, however, kicking myself for not removing the ceramic chicken on the cabinet to the left, along with the paper towel dispenser! Without those, more of the kitchen could have been seen down the far hallway. The piece of a chair poking into the right side of the composition is a small distraction that could have been easily cropped out.

▶ **KITCHEN CABINETS.** A big selling point for this kitchen was the cabinetry, so I tried to get as much of it in as possible with this angle. I also wanted to include the large pantry room that sits next to the refrigerator. I made sure the light was on in the pantry to make it as visible as possible, but looking at it now, I wish I'd used the local adjustment brush in Lightroom to bring out more shadow detail. With all the details going on in the kitchen area, as well as its overall brightness in the composition, the dark chair back in the lower right foreground is not as obvious as it could have been. However, it *is* a distraction and could have been easily moved out of the way before taking this shot!

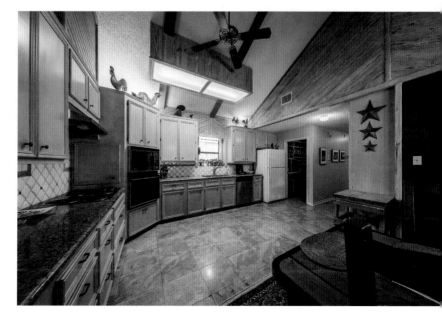

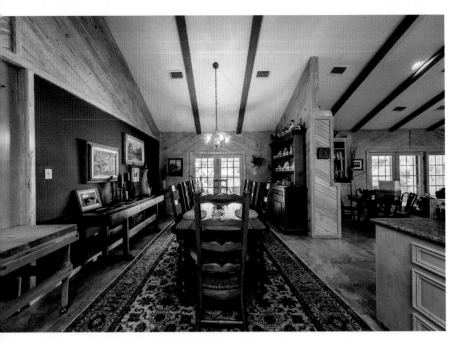

◄ OPEN FLOOR PLAN. I shot this image to include some of the living room. It helps to convey the open, airy layout of the floor plan. I moved the camera back as far as I could and stopped just before the cabinets on the right started to obstruct the view of the living room.

▼ KITCHEN, FINAL VIEW. This was the final view of the kitchen taken to show the cabinets and the functionality of the layout. It also includes enough of the living room to keep the viewer oriented. Notice that the corner where the oven is located is squared with the camera and the bottom and top are parallel with the bottom of the frame.

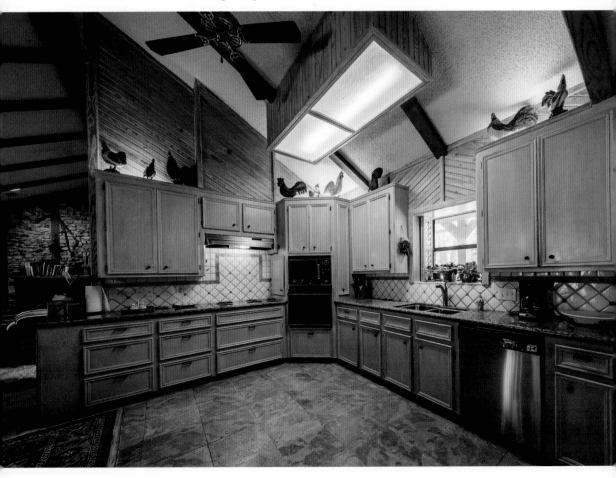

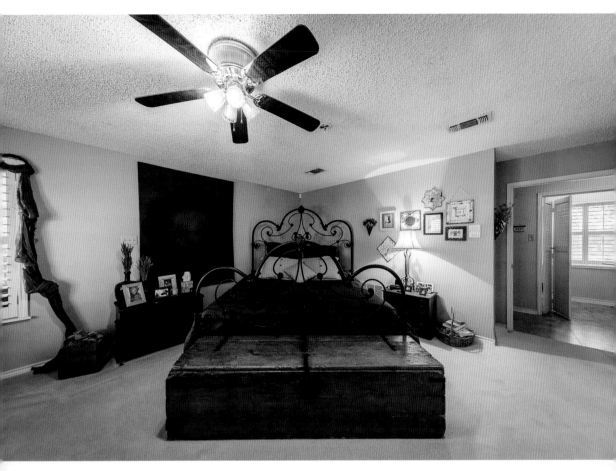

▲ MASTER BEDROOM. This angle of the master bedroom was chosen because the orientation of the bed in the room made an entryway shot look awkward. This view also allowed a view of the laundry area across the hallway. Once again, the bottom line of the bed is aligned parallel to the bottom of the frame to add impact to the composition.

▶ ENTRY TO MASTER BATH. This shot of the entry to the master bath includes enough of the master bedroom to show how they're related. A master suite layout like this is a selling feature that needs to be emphasized. This camera angle does that, and it shows how big the bathroom area is as well.

▲ MASTER BATHROOM, VIEW 1. I moved just inside the doorway to the bathroom to include as much as possible of the entire layout and to emphasize its overall size.

▼ MASTER BATHROOM, VIEW 2. This angle shows more details of the vanity areas and shower (notice the glass shower door is purposely opened). When you get into a bathroom like this, it's a real challenge to keep yourself out of the picture with all the mirrors! Can you find my camera's lens and part of the tripod in this shot? When it isn't obvious, I don't bother to remove it in post-processing. However, sometimes you have no option.

The 2-second delay on my shutter usually allows *me* to get out of the picture, but the camera and tripod are sometimes still visible. Sometimes just lowering the camera height or positioning an object on a countertop to hide it will work. When none of that is possible, at least try to position the camera against a background that's easy to clone.

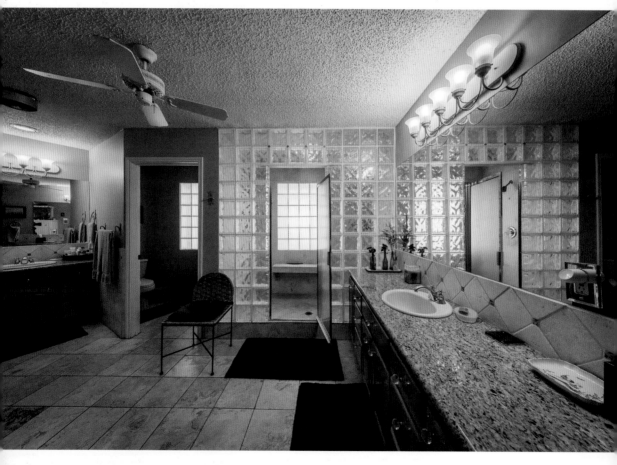

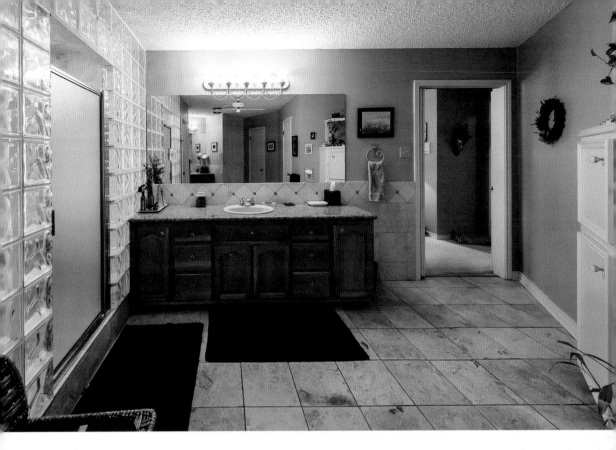

▲ MASTER BATHROOM, VIEW 3. This angle is one of those that will show your camera no matter what you do. In this case, I positioned the tripod so that the door showing in the middle of the mirror was directly behind my camera. This allowed me to use the cloning tool in Lightroom to remove it. More complicated backgrounds will require using Photoshop to do the work. Two compositional notes. It wouldn't have been that difficult to move the chair (in the lower-left corner) out of the way. And, the distraction of the plant coming into the frame in the lower right should have been taken away as well.

▼ SMALL BEDROOM. This is a two-wall composition that I typically use for small bedrooms. In hindsight, I can see that the verticals could be improved in this shot. By straightening them better, I think the blurry object on the far left (lower corner) would have been eliminated.

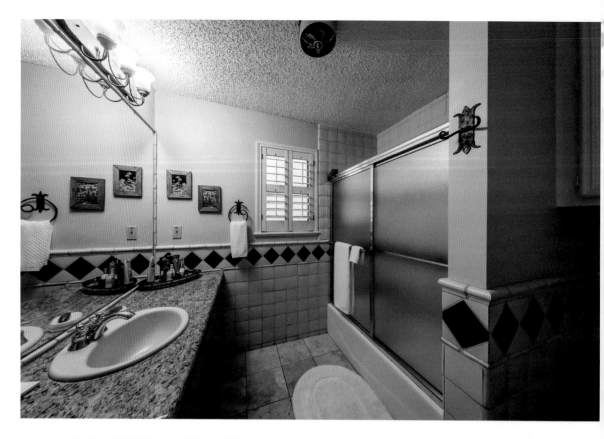

▲ HALL BATHROOM. This hall bathroom was shot at this angle to show as much as possible. It's not as distracting as some, but the throw rug in front of the tub could have been moved out of the composition. There's also the corner of a white object sticking into the frame from the lower left that should have been cropped out. The tray in the corner of the counter top with all of the toiletries on it should have been cleared off prior to the shot as well. It's far enough away in this view to only be a minor distraction, but in general you should clear all items like this from a bathroom counter.

▼ UTILITY ROOM. This utility room and guest kitchen is a nice selling feature. This is a case where the throw rug works nicely in the composition since it's kept squared off with the bottom of the frame. There's an unidentifiable dark object on the floor in the back right of the frame that should have been removed. In this case, I recall it being heavy, and it was something the home owner should have hidden away prior to the shoot. Sometimes you just have to live with things like this.

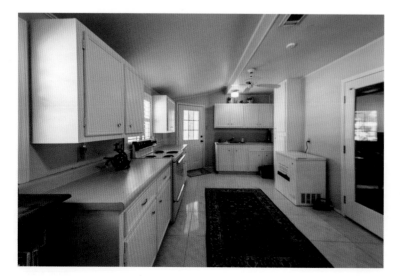

▶ **TRANSITIONAL IMAGE.** This isn't a particularly beautiful shot, but it was included to let the viewer know that the next bedroom shot is on the second floor.

▶ **SMALL BEDROOM.** This bedroom was very small so the best angle to shoot it was straight on. Some of the objects on the night table to the right could have been removed or rearranged. The board leaning against the wall on the floor should have been hidden, as well.

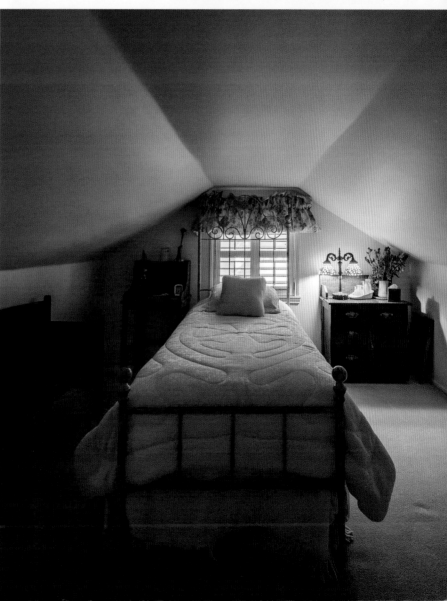

7. SAMPLE HOME 3

▶ **STRAIGHT-ON VIEW.** This straight on shot of the exterior front of the house is the usual view many realtors like for their listing thumbnails. I try to take this view for every home as a choice for the listing agent, but in my opinion this view often lacks impact.

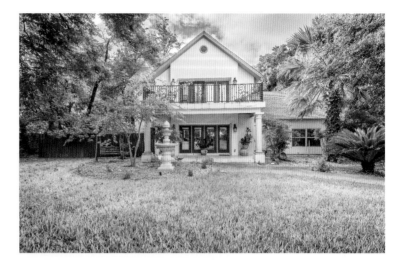

▼ **A MORE DRAMATIC COMPOSITION.** This angle offers the agent a more dramatic composition of the front of the home, and still manages to show off the main features. The beautiful glass doors of the entryway and the balcony off the master bedroom above are better displayed in this angle with the trees framing them, and the brick walkway acting to literally lead the viewer's eye to both elements.

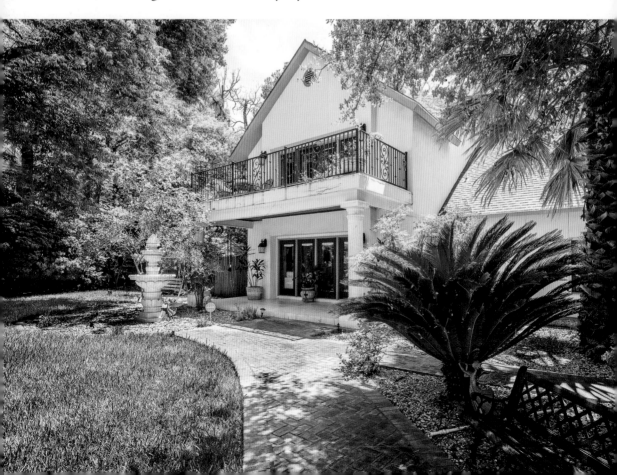

▶ **PORCH DETAIL.** This angle showing a close-up of one of the front porch columns isn't particularly necessary, but this detail of a structural element might sway a potential buyer since this is an older home.

▼ **DRONE VIEW 1.** This is an aerial view from the drone of the front exterior. The agent wanted aerials done, but with a home that's as heavily covered with big trees like this, I wouldn't have normally recommended it. There just weren't many good, open angles to shoot through the tree canopy. However, the layout of the master bedroom balcony area does show up nicely. *Exposure settings: ISO 100, f/2.8, and ¹⁄₁₀₀ second.*

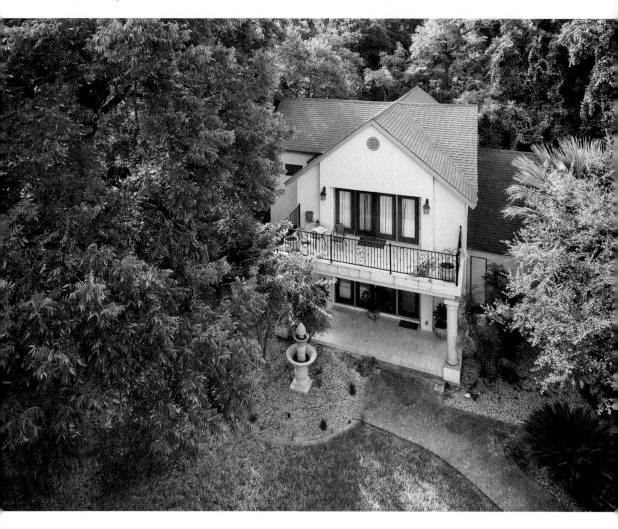

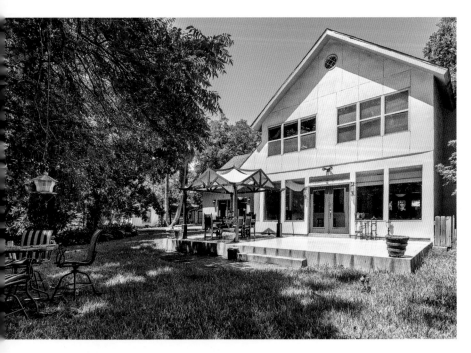

etation and trees because of potential movement of the branches and leaves, but in this case the wind was very calm. The result is a very natural-looking, restful image that brings out the best in the home's architecture. It also shows the functionality of the backyard area.

▼ **ANOTHER ANGLE.** This angle from

▲ **EXPOSURE CHALLENGE.** This view of the backyard had to be shot with HDR, multiple exposures due to the extremes of brightness in the sunlight and the darkness of the shady areas. HDR is not my first choice for outdoor shots that include a lot of veg-

the other side completes the "story" of the rear of the home. The three doors on the left lead into the den area and will be visible in a future interior shot. This angle better conveys the large size of the backyard area.

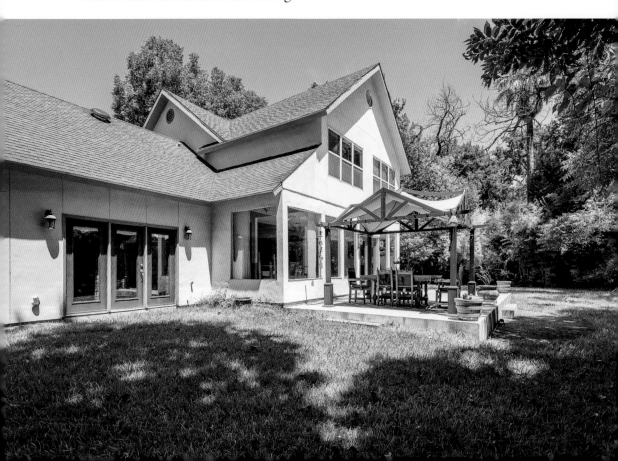

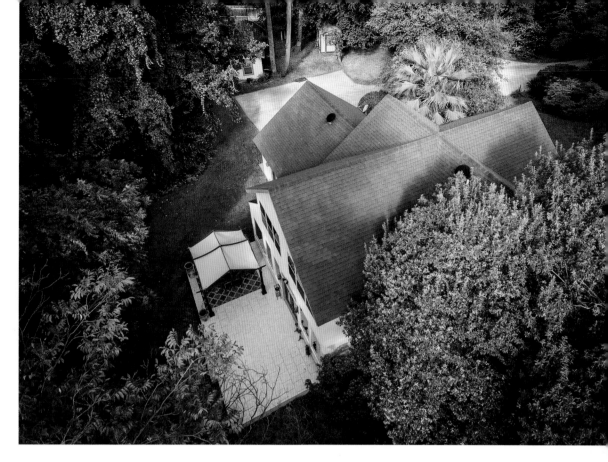

▲ DRONE VIEW 2. This aerial shows a potential buyer a better view of the layout of the home within the lot, and also shows a small guest cottage and storage shed that's part of the property. *Exposure settings: ISO 100, f/2.8, and $\frac{1}{230}$ second.*

▶ SHOW THE FLOW. This angle taken from the back window shows three important areas of the home in one shot. The kitchen, the breakfast area, and part of the den (the blue-walled room in the distance). It's an important view which shows how these rooms interrelate. The kitchen has been very well staged, with everything removed from the counter tops and the stools neatly lined up in front of the serving bar. The beau-tiful arched spout of the sink was purposely turned sideways to the camera to show it off. I turned the corner lamp off before the shot, because I didn't want the incandescent bulb to discolor the area around the table with orange light so near a huge natural light source (blue). The ceiling lights were left on as accents, because they weren't strong enough to change the color balance of the overall scene.

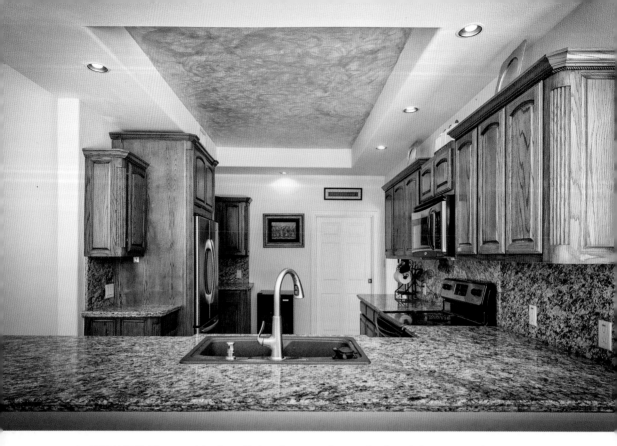

▲ **KITCHEN.** To get this shot, I simply moved into the breakfast area and set up a one-point perspective shot of the kitchen. Once again, the faucet was angled enough to show off its shape and the counters inside the kitchen were cleaned off to showcase the beautiful granite counter tops. Notice that by squaring up the far wall to the camera's lens, the recessed ceiling lines are perfectly parallel to one another and with the top and bottom of the frame.

◄ **ANOTHER ANGLE.** This shot looks back at the spot where I was standing for the first interior image (page 77, bottom), and completes the viewer's understanding of how all this space relates. I purposely placed the far vertical line of the last window at the one-third point of the composition to give the image more impact.

▲ **EXTRA PUNCH.** This angle helps to incorporate the breakfast table with the total room view. The interesting angles formed with the windows' perspective lines converging with the vertical column at the left one-third area of the composition adds an extra punch.

▶ **THREE DOORWAYS.** This image shows the three doorways from the den that we saw from the last exterior shot of the backyard. Notice the white bridge outside, which spans a small waterway running through the landscaping. The door mat on the right doesn't bother me, but the electrical cord to the right of it does. These are the little things that you hopefully learn to see and clean up before you take the shot!

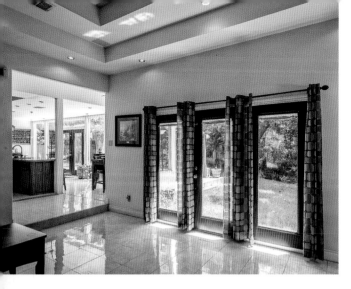

ally have been placed *before* the one on the previous page. Both images show the three doors in the den, but this one looks back at the kitchen area. That leaves no doubt as to where the den is in the home.

Look back at the previous page and notice that, as I sequenced it here (for the purpose of demonstration), there is an abrupt transition from the last kitchen shot to the first den shot. That leaves the viewer scratching their heads as to where they just jumped to!

▲ **SEQUENCING.** I've mentioned before how important it is to sequence your shots before you deliver them to your agent. By including a recognizable element from one image in the next one, you can keep the viewer well-oriented. As you move through the home, the proper sequence clearly reveals the relationship between the spaces.

To transition us from the kitchen to the den, the image shown above should actu-

▼ **BACKYARD VIEW.** Moving back into the kitchen, this image was taken to show the prospective buyer the beautiful view of the backyard from the kitchen. It also shows more detail of the cabinets and the appliances not visible from the other kitchen shots.

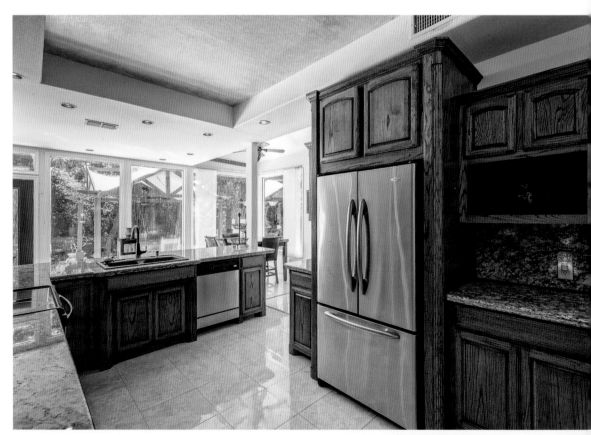

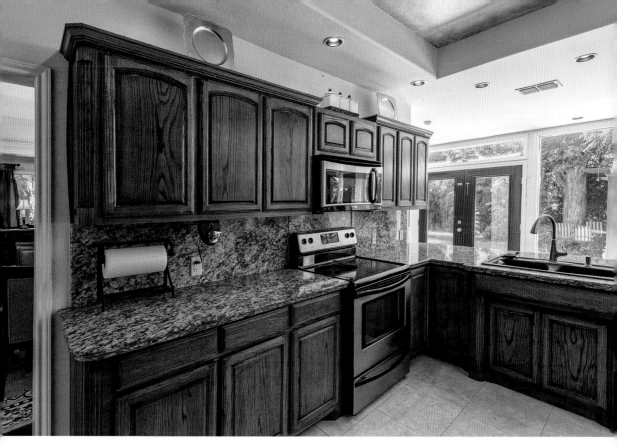

▲ **ANOTHER ANGLE.** This is another view of the other side of the kitchen with a peak through the opening to the formal dining area. This will provide context for the next shot of the dining room.

▶ **FORMAL DINING ROOM.** Here's the formal dining room shot toward the backyard, and showing the entry to the kitchen. It also shows a view of the entertainment and sitting area off to the left. Normally I would have shot another angle of the dining room looking back in the opposite direction back into the formal living room, but as it often is in shooting real estate, it would have exposed some unwanted clutter in the sitting room that would not have been easy to relocate and impossible to remove in post-processing.

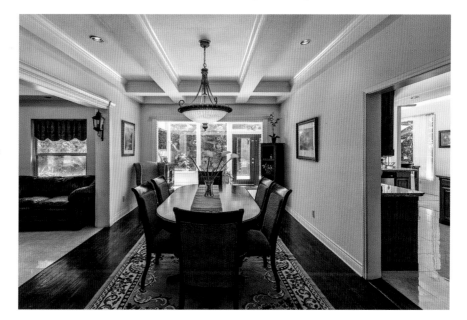

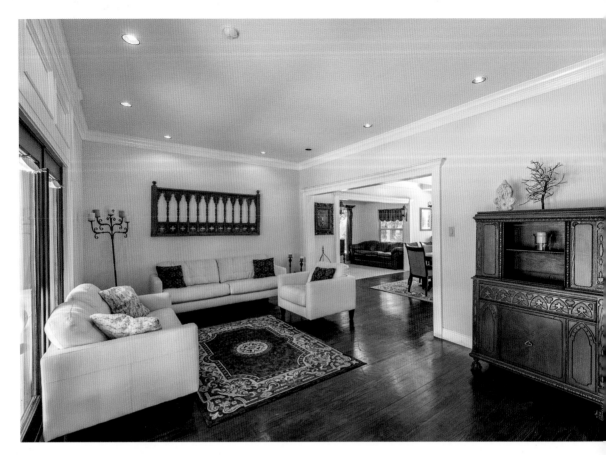

▲ LIVING ROOM. This view of the living room shows enough of the sitting area and dining room to keep the viewer oriented in the home. The room is perfectly staged, and even the rug works beautifully in the composition.

▼ VIEW OF FRONT YARD. Showing this view of the living room with the view of the front yard gives the prospective buyer a complete impression of the spaces from front to back. This time, the floor mat in front of the left door should have been removed. You can see that the exaggerated size of the far-left door is a result of the 11mm lens again. This might look better if I'd cropped it to about half of its width by bringing down the top-left corner of the Crop tool and taking out some of the ceiling with it.

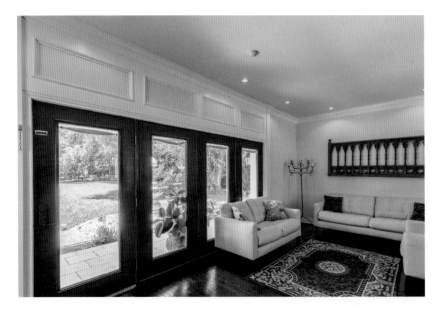

► **TRANSITION TO SECOND FLOOR.** Showing the stairway reveals the home's second floor. It might look better if the image had been cropped from the upper-right corner downward to take the chest on the right side completely out of the frame.

▼ **MASTER SUITE.** This angle on the master bedroom suite shows part of a doorway to the balcony. It also shows some of the entry to the master bath on the right. The bed could have been staged better by the home owner (by adding a cover to hide the mattresses). I could also have improved the shot by moving the stool at the foot of the bed out of the frame.

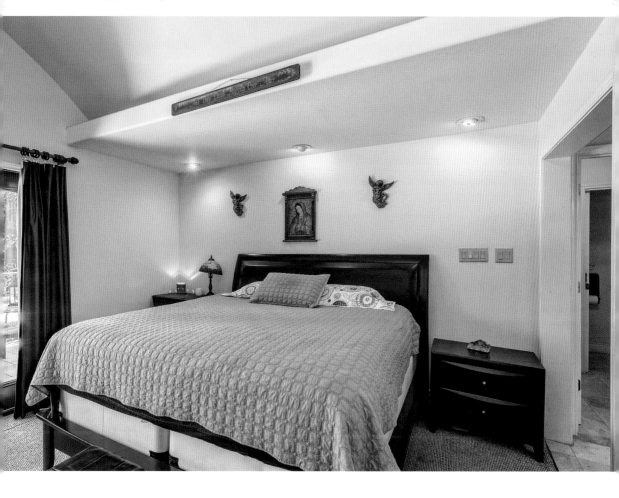

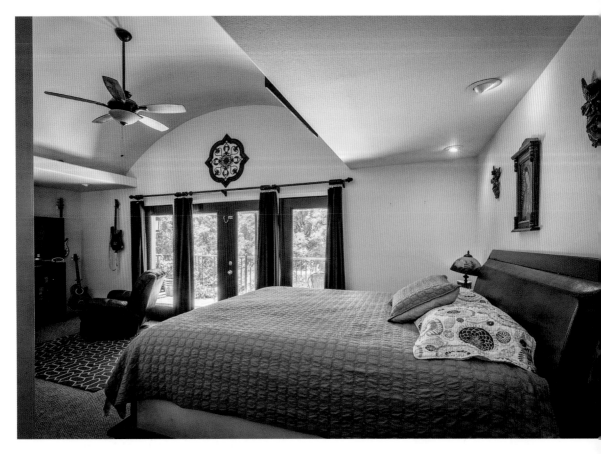

▲ BEDROOM. This is probably the best angle of the bedroom; it gets most of the room's contents into the frame, along with the nice view through the doors. If the camera had been angled more to the left, I think this shot could have been even more informative. The right side of the frame could be brought around to align with right edge of the closest pillow, which would in turn reveal more of the opposite wall with the television.

▼ STAGING AND REFLECTIONS. This is one of those bathrooms that make it impossible to shoot without a reflection of the camera in the mirror! This shot required extensive cloning and compositing to remove the camera and tripod out of the background with the bed. The staging of the bathroom is flawless. Notice that all the toiletry items had been removed. The nice towel stand in the corner adds just enough texture to break up the repetitiveness of the granite top.

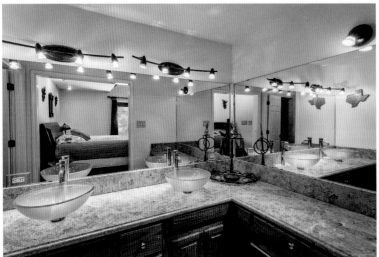

▶ **HALL BATHROOM.** This is a hall bathroom located next door to another bedroom. This is a simple two-wall shot of a small room. I'd like to point out something here since it's so obvious in this image. Notice how much detail is seen in the light fixtures over the sink. This is not an accident. I purposely shoot my HDR sequences as dark as it takes to keep detail in these fixtures. I'll keep an eye on the highlight alert on the image in Live View until I've got detail in all but a small area on a light bulb. This is a stylistic choice, and it's just the way I like my images to look.

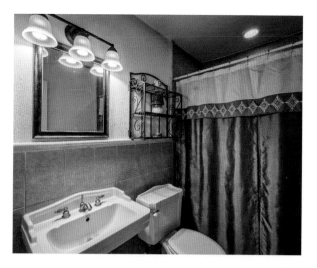

▼ **ANOTHER BEDROOM.** This is the bedroom located next door, and there are a number of small details that I wish had been cleaned up. First, the items on the top shelf of the bedside cabinet should have been removed before I got there. They weren't enough of an eyesore for me to take the time to hide them, so I let it stand. One thing I could have easily fixed was the electrical cord plugged in under the window. It could have been hidden behind the chest of drawers for the shot and then plugged back in. Also, the position of the throw rug at the end of the bed is distracting. If it had been centered between the bed's legs, it might have been okay.

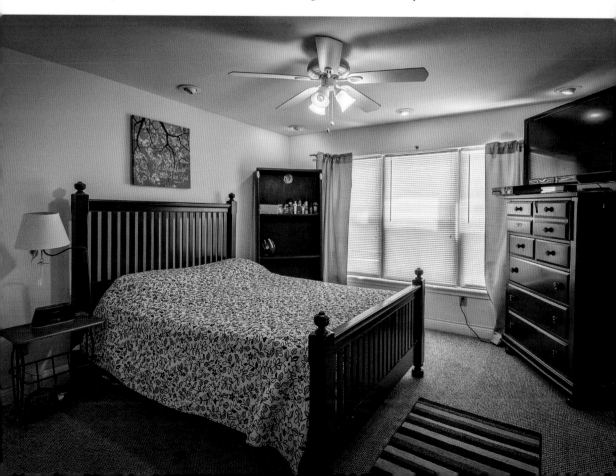

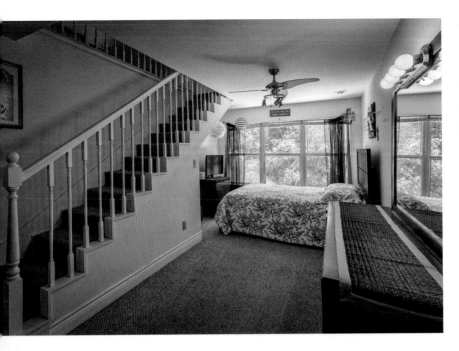

◄ **UNIQUE BEDROOM LAYOUT.** This is a uniquely laid out bedroom around the corner from the previous room. It also shows a stairway leading to a third-floor room shown in the next image. To further illustrate my point on the bathroom light fixtures, notice how the fixtures in this room also show attractive detail in the globes.

▼ **PLAYROOM.** This is a small children's play room and you can see the stairs leading down to the previous bedroom. This room could have easily been too cluttered with toys, but I think the owners did a tremendous job of staging this room.

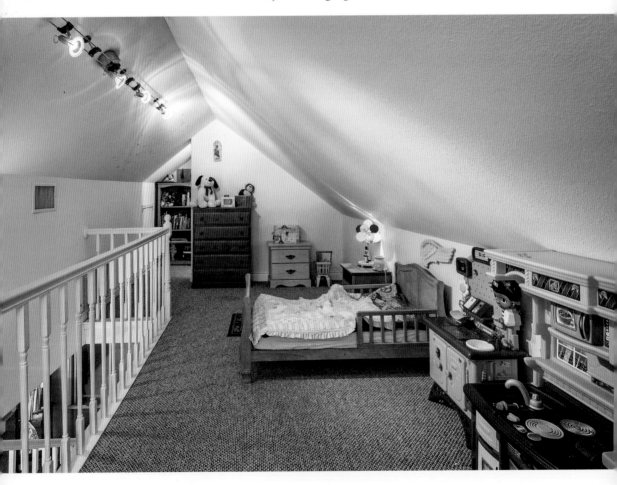

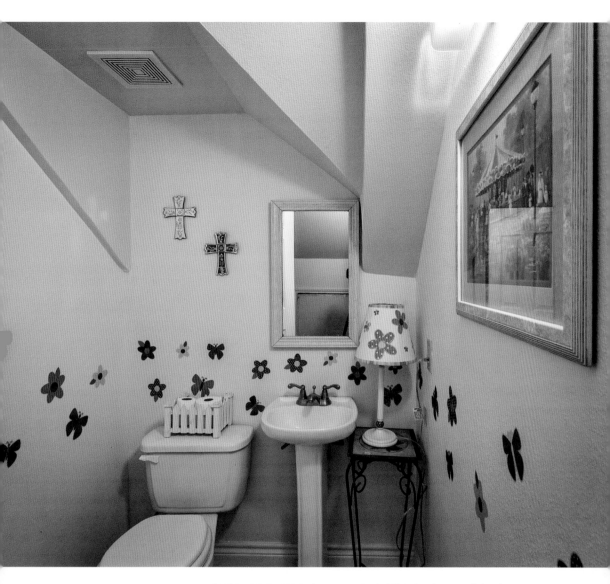

▲ **MINIMIZE VERTICAL IMAGES.** This is the small bathroom located behind the back wall of the play room. Note that I cropped this image close to a square. Vertical images should be done sparingly in real estate photography because the multiple listing services (MLS) online galleries usually have to resize them to fit horizontal frames. This results in small images that are harder to see than horizontals.

8. SAMPLE HOME 4

▼ **TWILIGHT EXTERIOR.** This home presented a unique problem for the exterior front shot, and it was decided that the best way to solve it was to do a twilight shot instead of a normal daytime capture. The problem is that the home's front door is facing the northwest. So, no matter what time of day it's shot, the front will be in shade and backlit. This creates potential lens flare problems and, at a minimum, flat contrast in the image. By waiting until dusk, those problems are eliminated. A typical twilight shot captures that perfect moment when the proper exposure for the window lights is the same as the exposure for the sky. This time typically happens around 15 to 20 minutes after the sun has set. You must get to the property at least 30 to 45 minutes prior to that to get everything set up inside and outside the home. All interior lights must be turned on; if they're available, turn on the exterior and landscape lights as well. Be careful with exterior lights because they can often overpower the interior lighting in your shot. If that's the case, I usually opt for keeping them off. Another thing that you need to be careful with in post-processing is overdoing the orange color of the lighting. It's usually necessary to tone the color down a bit by desaturating the oranges and yellows with the HSL sliders in Lightroom. The orange in a couple of these windows might be a bit much for some tastes, but it was much more pronounced out of the camera. *Exposure settings: ISO 400, f/5.6, and $^1/_{125}$ second.*

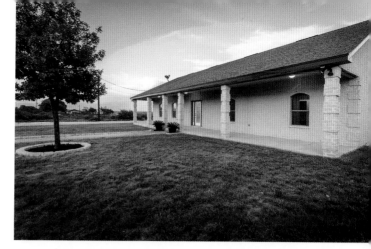

▶ **ANOTHER OPTION** *(top).* I took this angle to provide the client another option for the front thumbnail. The porch lights are now visible and you can also see a little more of the surrounding area. The tree was included to balance the composition of the home at this angle. *Exposure settings: ISO 400, f/4.5, and ¹⁄₈₀ second.*

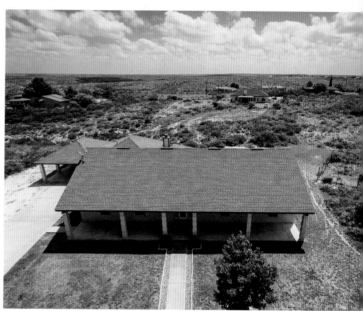

▶ **DRONE VIEW 1** *(center).* My client also opted for some aerial images to to show the lakeside location of this home. This shot is taken of the front in the morning following the twilight and it shows the size of the lot, as well as it's orientation in the neighborhood. It also shows the dog pen off to the right side of the home. This would have been a very difficult feature to display with a ground-based shot. *Exposure settings: ISO100, f/2.8, and ¹⁄₁₄₀₀ second.*

▶ **BACK OF THE HOUSE** *(bottom).* This shot of the back of the house is nicely lit by the partly cloudy sky south of the home. The owner has not done much in the way of landscaping, but this could actually be a selling feature by allowing a buyer to start with a relatively clean slate to create their own vision. One item that should always be removed during the "staging" for exterior shots is garden hoses. You'll notice that there's one showing on the far left of the home that I did not see until later. It could have been pulled closer to the side of the house and hidden from view.

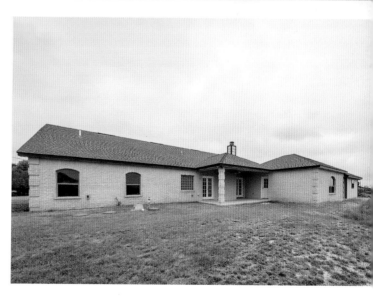

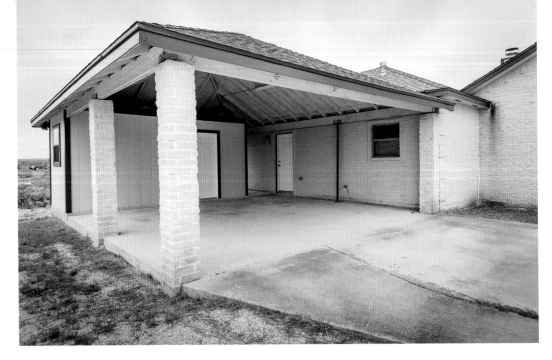

▲ AN IMPORTANT FEATURE. This shot of the carport is not particularly attractive, but its size and the large outdoor storage area seen in the back are selling features that have to be documented for a potential buyer. This angle gives the composition some drama by showing the lines on the carport roof and the roof line of the main house (on the right) converging at the one-third vertical of the frame.

▼ A MORE DRAMATIC ANGLE. This is an even more dramatic composition of the carport space. It uses the ceiling rafters as a texture while the roof lines once again converge at the one-third location near the storage room door.

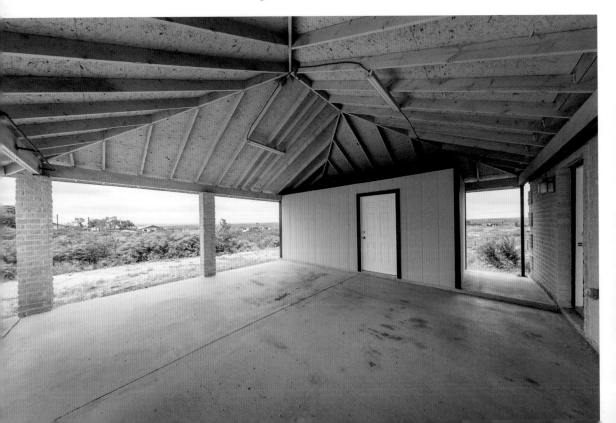

► **DRONE VIEW 2.** This aerial shot is crucial to showing a buyer that this home is located on a lake, and it also shows the quality of the nearby homes in the neighborhood. It gives the buyer a good feel for the floor plan of the home which is difficult to grasp by just looking at the front and background shots. *Exposure settings: ISO 100, f/2.8, and ¹⁄₁₇₀₀ second.*

▼ **DRONE VIEW 3.** Moving around to capture this side of the house completes the viewer's orientation of the surrounding neighborhood and the lake. To the extent you can, try to avoid placing the horizon line in the middle of the frame. The rule of thumb in any landscape is to keep the horizon on a one third point in the frame as shown here. Sometimes the sky is dramatic enough to warrant the two-thirds portion of the composition, but usually the foreground dominates as it does in this image. *Exposure settings: ISO 100, f/2.8, and ¹⁄₁₅₀₀ second.*

▲ AN EMPTY HOUSE. I wanted to include at least one empty house in the sample homes. For me, they're by far the most difficult to photograph. When I'm faced with this situation, I usually try to take more shots at different angles of the large living spaces. Since there isn't any furniture to limit where you can set up the camera, it's easier to find multiple angles. This angle starts at the front entryway looking toward the back of the home and the fireplace. I chose a one-point perspective here, keeping the lens aligned with the back wall. I've placed the kitchen doorway on the left and the vertical dividing wall on the right at the one-third lines to anchor the composition. The leading lines of the floor tiles also draw attention to the best feature in the living room, which is the fireplace. The lights of the fixture seen in the upper left of the frame are a distraction, but it was not possible to crop them out without losing some of the interesting shapes on the ceiling. It would have been possible to clone them out in Photoshop, but I didn't think they warranted that much effort.

▼ ANOTHER VIEW. For this shot, I moved to the center of the room to get a closer view of the fireplace and the patio doors. You'll notice again, I've kept most of the detail in the fan's light fixture.

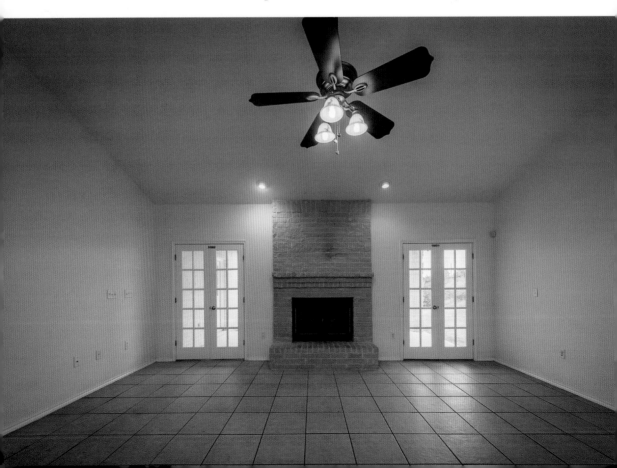

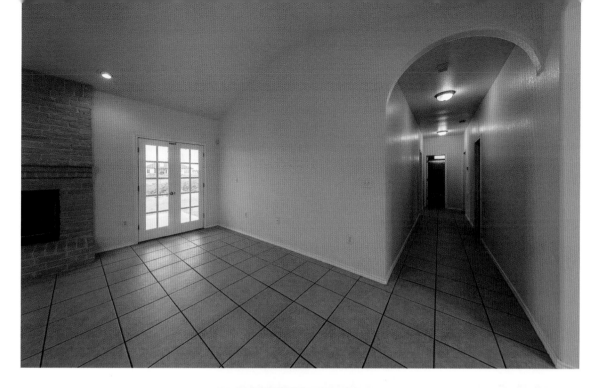

▲ BEDROOM HALLWAY.

To present the entire living room and formal dining room space as completely as possible, I decided to rotate around in roughly 90 degree increments. This shot was taken of the bedroom hallway, keeping the recognizable elements of the patio door and part of the fireplace in the frame. The arch of the hallway entry curves down into a vertical that's placed

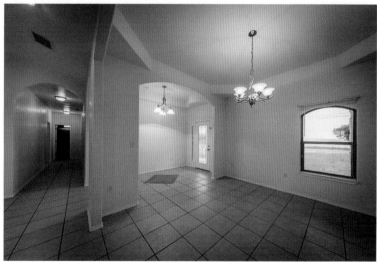

on the right one-third point, and the patio doors are roughly placed on the left one-third point.

▶ **FRONT ENTRYWAY.** Continuing around, keeping the hallway visible, I'm now pointed at the front entryway. The area where the left side of the ceiling hits the top of the frame converges with the vertical of the wall on the left one-third spot, and you'll notice that the chandelier in the dining room sits almost exactly on the intersection of the upper and the right one-third location! I want to point out an area of the floor tile in front of the door. This looks a bit like a throw rug, but it's a design inset with the floor tiles. You'll see this in another shot and it's somewhat distracting.

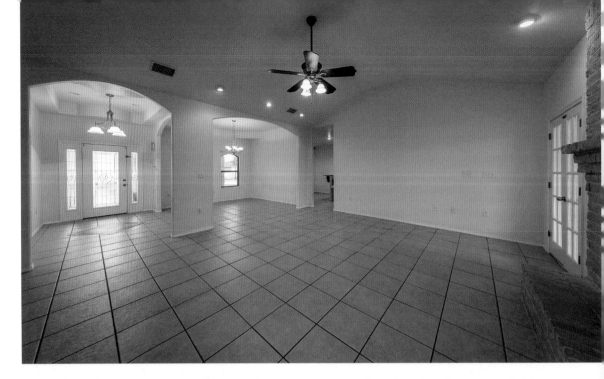

▲ BROAD VIEW OF THE SPACE. After establishing where the front door is in the previous shot, I moved back in the corner of the living room to get this overview of the entire space along with the entry to the kitchen area near the center.

▼ TRY A DIFFERENT CROP. Now, I've moved directly across from the wall where the kitchen entry is located, and shot this one-point perspective showing another expansive view of the living area. In the image on the left, you'll notice the brown, pointed shape coming into the frame from the bottom left. This is the floor tile design I mentioned earlier. Even though it's very distracting, I didn't think (at the time) that I could crop it out of the composition without sacrificing some of the other elements I wanted to include in the shot. When I re-think it now, I realize I could actually have improved the composition by pulling in the crop from the left and dragging it in equally from the top and bottom until the vertical of the wall rested on the one-third point, as shown in the right-hand image. This crop has the added benefit of also eliminating the distracting air conditioning register on the ceiling!

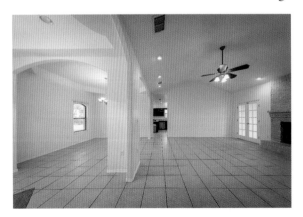

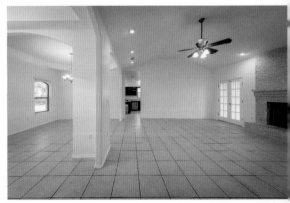

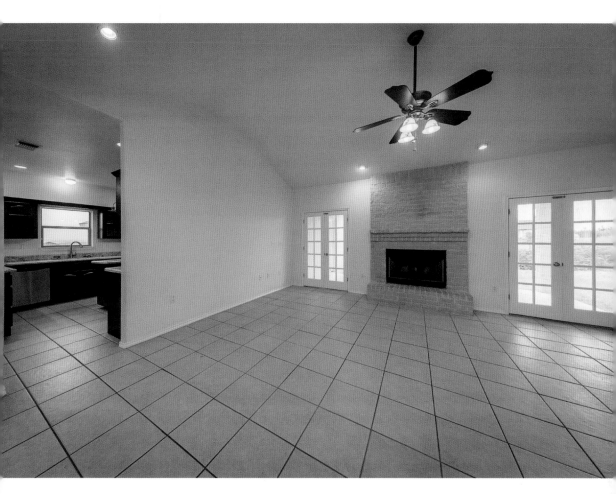

▲ **FROM THE LIVING ROOM TO THE KITCHEN.** This shot sets the viewer up for entering the kitchen area from the living room. The distortion from the 11mm lens is evident in the abnormal width of the kitchen entry. This shot would have looked much more natural if I'd zoomed in to the 20–24mm range. The shot still would have included plenty of the living room features to keep the viewer oriented.

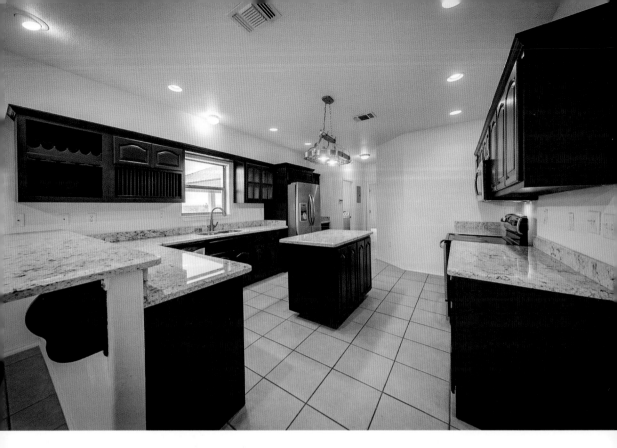

▲ APPLIANCES AND CABINETRY. This is an angle that includes the entire kitchen space, showing all the appliances and cabinetry and how they interrelate. It was taken from just inside the entryway from the living room. The angle was set to place the corner of the wall just past the center island on the one-third spot with the perspective lines of the cabinets and floor tiles converging into it.

▼ DETAIL SHOTS. Kitchens are always a good place to get detail shots of the appliances as well as other selling features. This is one of the most important areas of the home for many buyers, so it's hard to take too many good angles of the kitchen area. I set the camera up much higher than I normally do in order to include a detail of the pot and utensil hanging rack.

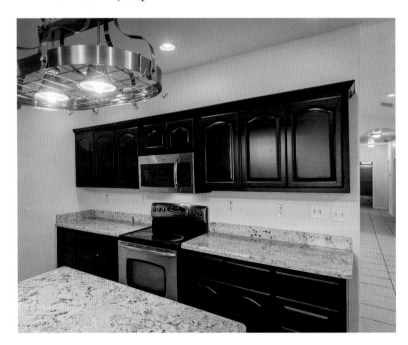

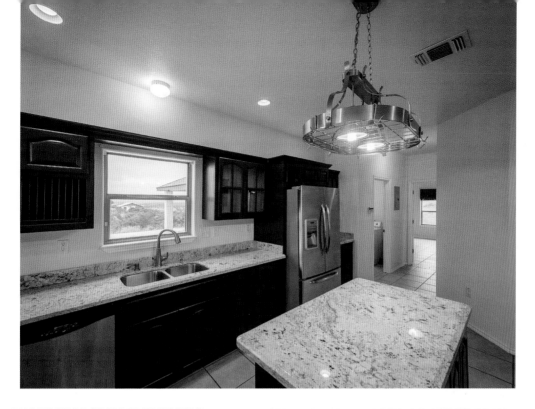

▲ PHOTOSHOP "IMPROVEMENTS."

This angle gives another closer view of the kitchen sink and prep area. I want to point out something here that we haven't discussed up until now: materially altering the appearance of the home (see sidebar). The reason I chose this photo to start the discussion is the scarred-up front of the dishwasher. I considered "fixing" this up at first, but then thought better of it, because the damage on the surface appeared to be permanent. On the other hand, I did make a major change to cover up a water damaged ceiling on a different home, because the agent and the seller assured me that they already had a contractor lined up to repair the leak and the damage. Ultimately it's your real estate agent who's going to be responsible for any material misrepresentations of the property.

MAKING MATERIAL ALTERATIONS. In general, this means changing something that's part of the permanent makeup of the home. Examples of this would be power lines that lead to the property, major parts of the landscaping, and any other permanent components of the property. There are lots of gray areas when it comes to making retouching decisions in real estate. One that gets argued about a lot is fixing lawns. Some photographers don't see anything wrong with completely fabricating a beautiful lawn, arguing that it's simply a temporary or easily altered feature. Others won't even fill in a brown spot on the lawn for fear of misrepresenting the property. My best advice on this is to go online and read as many discussions on the subject as possible, and then make up your own mind about how far you feel comfortable going.

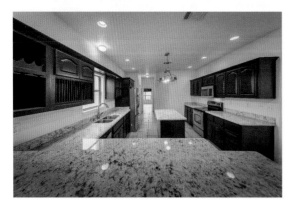 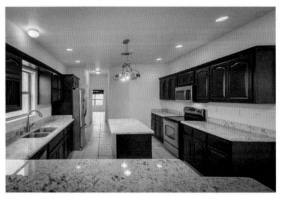

▲ CROPPING. I like this one-point perspective shot of the kitchen (left), because it also allows the viewer to see all the way through the hallway and to the back wall of the house. I think the composition would be better cropped in, as you see to the right. The excessive amount of countertop space in the foreground is eliminated and the obvious stretching of the cabinets on the left side is also concealed. It also allows placement of the hallway vanishing point on the one-third spot in the frame.

▼ WATCH THE DETAILS. This opposing angle shows the entire kitchen and includes the breakfast area. There isn't much to say about this image, but I would point out a detail. Notice my car as part of the "view" out the sink window! It never looks good to do exteriors with cars in the driveway or on the street in front of the house. It also doesn't look good to see cars obstructing window views from the inside. Always be careful when you park your vehicle outside a home, and make sure it won't be visible from the inside windows. In this case, I thought I'd done that—but I didn't anticipate this angle. This would be especially true if you have a shiny red convertible that immediately draws attention to itself! Having it show up prominently in a window can take a viewer's attention away from what they're supposed to be looking at inside.

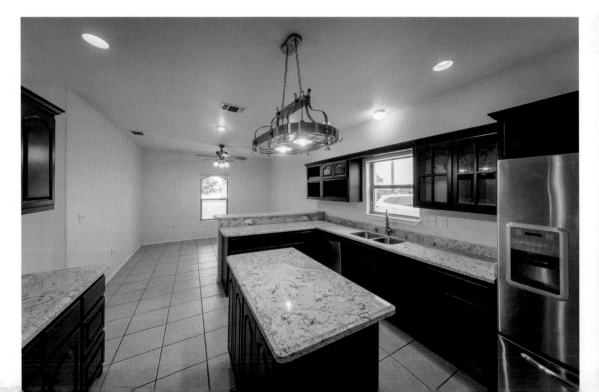

▶ **CABINETRY AND APPLIANCES.** I wanted to give the prospective buyer a look at the variety of cabinets this kitchen offered, a definite selling point. There's a wine rack on the far left, an area underneath a cabinet next to the sink with dividers, and some attractive cabinets with window-paned doors. The refrigerator is also a high-end model that would be an asset as well, and this view gives a detailed look.

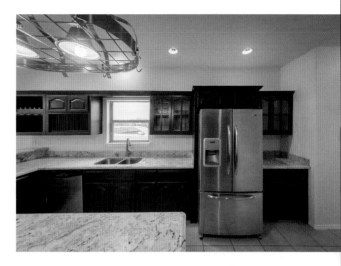

▼ **SMALL BEDROOM.** Now we get into the least exciting areas of the home that most agents are going to want shot regardless: the small bedrooms. The recessed ceilings in this one make it look better than most, so I made a special effort to include as much of it as possible. For most small bedrooms, a two-wall corner shot is just fine. These should take a minimum of time to shoot.

◄ SPECIAL FEATURES.
If you have a special feature (like a large closet or a small bathroom) that is accessible from the room, you should shoot the angle that includes their doors or entryways in the shot as best you can. Such details as the recessed ceiling here, along with the nice fan and light, help to add a little extra interest. Notice I have plenty of detail in the light fixture.

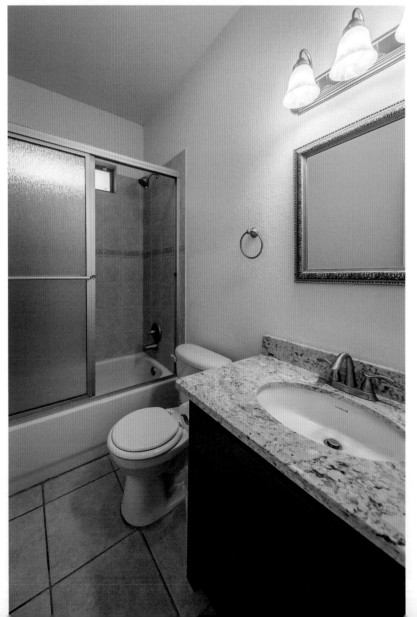

◄ SMALL BATHROOM. This is a straight-forward shot of a typical small bathroom. Make sure the toilet seat is down and, when it's practical, try to open a shower door like this to reveal the tile pattern inside. Remove any clutter from the vanity tops and inside the shower. I made this a vertical composition because it was too tight to do otherwise. However, when possible, I try my best to get horizontal orientations.

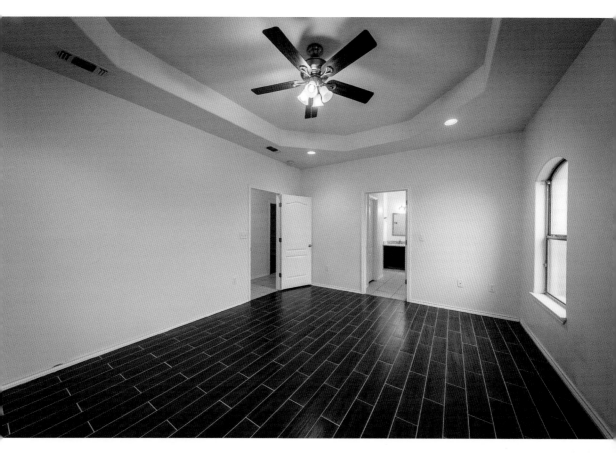

▲ MASTER SUITE. This is the master bedroom suite. The best angle for this was looking back at the entry door as well as the entry to the bathroom. Having a master bathroom with direct access to the bedroom is always a desirable feature you want to showcase when possible. Doing some Monday morning quarterbacking again, I think this room would have looked better with a one-point perspective shot aimed directly into the bathroom entryway.

▼ MASTER BATHROOM. This was the best angle to shoot this bathroom. It gets the entire vanity area in the shot as well as the spa tub area.

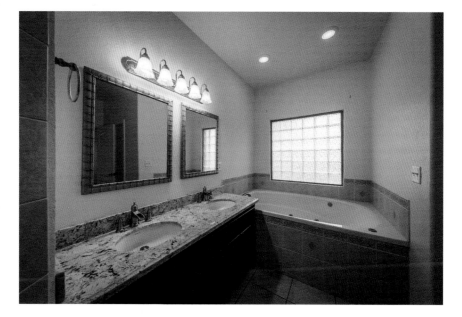

9. SAMPLE HOME 5

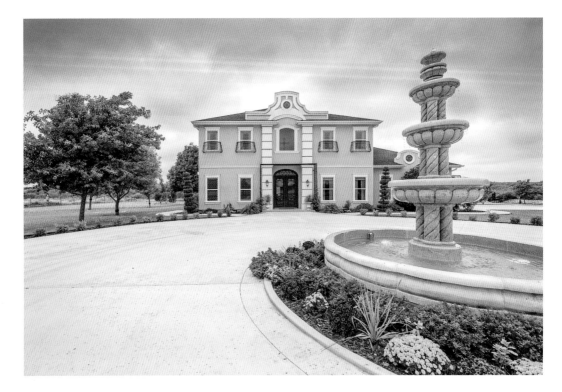

▲ **SKY ENHANCEMENT.** This home was one of my recent assignments. The complex sits on a 6-acre property that borders a small creek. The property was shot on one day and then, two days later, twilight photos were taken. On the day that the original exterior/interior photography was done, the skies were overcast the entire time. By utilizing a technique I pointed out in the post-processing chapter, I was able to create the impression that this was a bright, partly cloudy day! I "painted" selected areas of the sky with the Local Adjustment brush color-temperature slider set to –65, which resulted in a natural-looking blue sky.

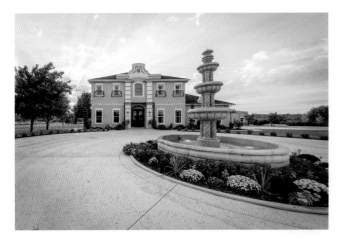

▼ **ALTERNATE VERSION.** Two days later, this shot was taken about 30 minutes before sunset while I was waiting for the optimal twilight time (15–30 minutes after sunset) to arrive. I used nearly the same angle as in the previous shot to give my client another option for the exterior thumbnail. *Exposure settings: ISO 400, f/8.0, and 1/320 second.*

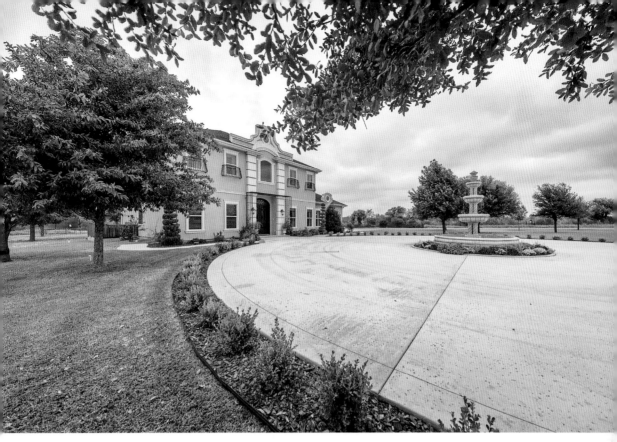

▲ ANOTHER ANGLE. This angle was chosen to give a more dramatic view of the entry driveway and fountain. Notice the placement of the home on the one-third line, with the curved line of the planter as well as the tree branches leading the viewer's eye right to the main subject. This image was shot under the original overcast conditions and was also brightened up with the sky-painting technique.

▶ COMPOSITION CHALLENGE. I wanted one ground-based shot that would include the two main buildings on the property, and show how they related to one another. Looking at the image more critically now, I think I probably should have cropped it with less grass in the foreground. A slightly panoramic aspect ratio of 1:2 would have put the horizon line at just about the one-third line from the bottom. Once again, the curved line of the driveway and the branches in the upper right lead the viewer's eye to the main house.

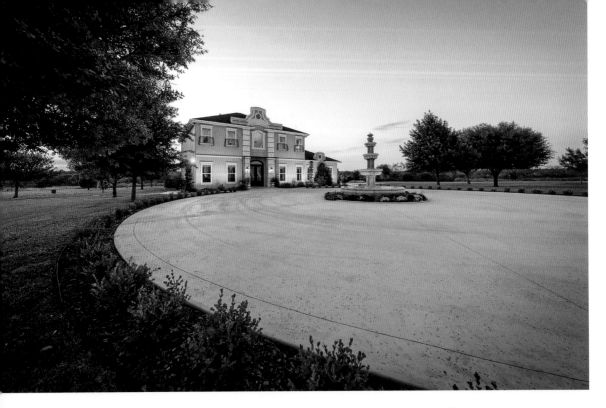

▲ **TWILIGHT 1.** This was the first twilight shot, and I chose a similar angle as for the image at the top of page 103. This shows off the fountain lights as well as the interior and exterior lights of the home. This exposure captured the maximum dynamic range for the scene with no blown-out highlights in the sky and good detail in the darker areas of the image. In this situation, where the home is backlit by the setting sun, care must be taken to maintain sky detail, even if you have to underexpose the front of the home slightly. It's easy to pull out shadow detail later using the Shadow slider in Lightroom. For twilight shots, I always take multiple exposures from the same location in 1- to 2-minute intervals, starting at approximately 15 minutes past sunset so I can catch that perfect balance of sky-to-interior light exposures. That time is usually right around 20 minutes after sunset. *Exposure settings: ISO 400, f/6.3, and ⅟₁₅ second.*

▼ **TWILIGHT 2.** This is another twilight shot I took from the side of the home after I'd gotten my perfect exposure of the front. I wanted to frame the home with the trees so that the home was sitting at the one-third area on the upper right. When I look back on it now, I think I missed a great opportunity here. If you notice, the trunk of the left-most tree cuts the base of the fountain right in half, hiding the lighted fountain spout. If I'd just moved in and a little to the right,

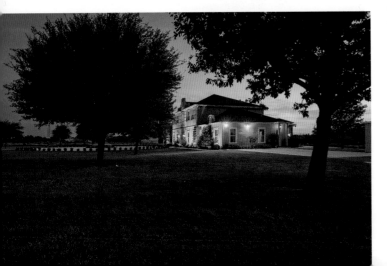

toward the foreground tree, I could have perfectly framed the entire fountain between the two trees on the left, while keeping the home still framed as it is now. Hindsight is often 20/20! *Exposure settings: ISO 400, f/6.3, and ¼ second.*

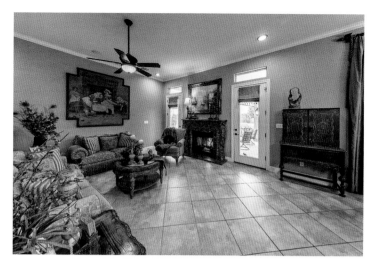

▶ **LIVING ROOM 1.** Even though it was around 85 degrees outside, the homeowners offered to light up the fireplace in the living room to create a cozy ambiance. It wasn't that hard since it was a natural gas fireplace, but it saved me the trouble of having to create a fire in Photoshop!

▶ **LIVING ROOM 2.** This angle of the living room includes enough of the fireplace to keep the viewer oriented and to maintain the same mood for this image. The long antique table on the left side presented me with a small problem that often comes up when shooting furniture with lamps sitting on top. There was an exposed electric cord dangling underneath, plugged into an outlet under the table. As you can see (or not see), I removed it (along with the outlet) to eliminate a huge distraction. Technically I materially changed the home by removing the outlet, but this is one of those judgment calls I make now and then. Such a minor cosmetic change improves the image without doing anything that would be noticed (or remembered) by a buyer during a visit to the home.

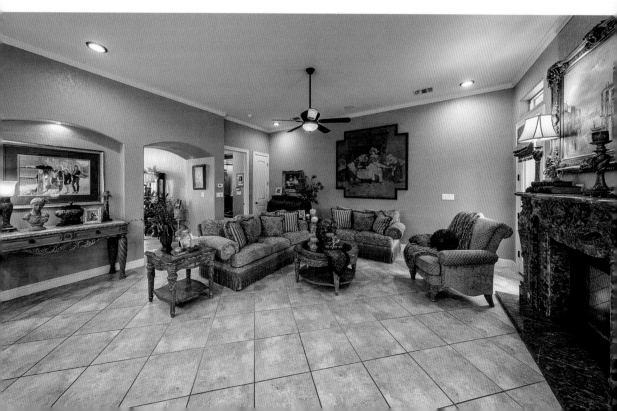

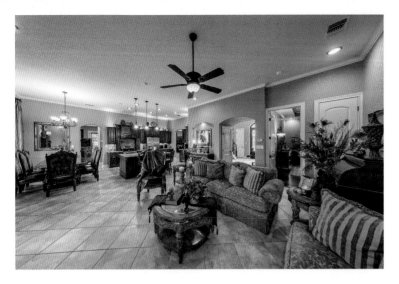

"This is another situation where a different crop can improve the image."

▲▼ **CROPPING, BEFORE AND AFTER.** For the image above, I moved back into the far corner of the living room to shoot back at the kitchen area to give an overview of the space. This is another situation where a different crop can improve the image. For the image below, I brought down the top horizontal line just past the base of the ceiling fan. This eliminated both ceiling distractions (the light at the upper left plus the air conditioning register and large ceiling light at the upper right) as well as some of the distortion on the dining room chairs at the left edge of the frame.

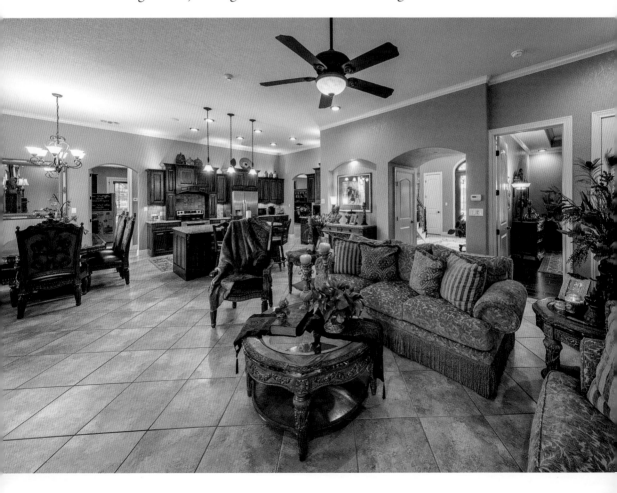

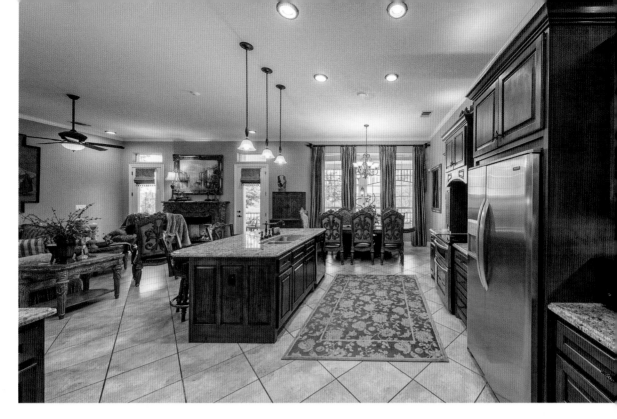

▲ **LIVING ROOM, ANOTHER VIEW.** Moving to this angle gives another full-space view of the kitchen and how it relates to the living room. I made sure the rug between the cabinets was perfectly straight so that I could use the bottom edge as a horizontal in the composition. Note that the horizontal line of the far wall is parallel with the bottom of the rug and the cabinet on its left. This is perfect one-point perspective.

▼ **DINING ROOM.** This is a shot of the formal dining room taken from the entry to the kitchen. The lines of the table converge toward the left one-third area, and the staircase banister leads down to the front door, which sits on the right one-third line.

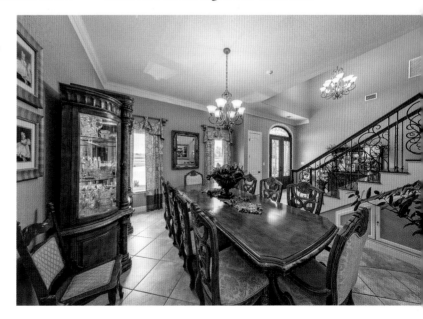

▲ **OPEN FLOOR PLAN.** This view from the opposite side of the dining room and front entry area captures the room and its relationship with the living room. If you look closely, you can see the top of the fireplace above the back of the couch. The shot is set up so that the staircase winds down and the bottom step ends near the bottom right one-third point. This also shows the buyer that there is a second floor to the home.

▼ **MASTER SUITE.** This is the master bedroom suite. If you look carefully, you'll see the living room fireplace through the opening on the right. The other door is the master bathroom entry door. The bathroom door is placed on the right one-third line and perspective lines of the ceiling converge nearby to add strength to the composition.

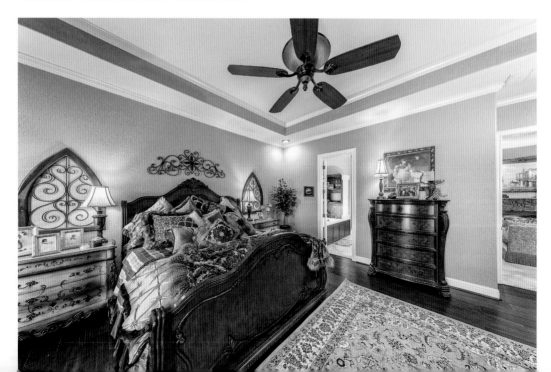

► **MASTER BATHROOM.** This is the master bathroom, shot back toward the bedroom entry. The camera was raised higher than normal for this shot so that the sinks could be seen in full, as well as the tub on the right. Notice the subtle detail in the light fixtures. The bathroom is perfectly staged with just enough accessories to give the area interest and texture, but not so much as to be cluttered. The mats on the floor were removed to reveal the beautiful tile patterns.

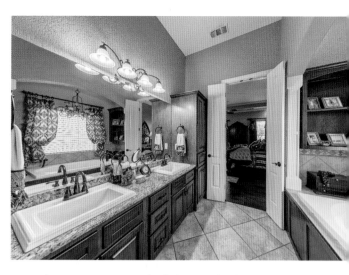

▼ **FRONT ENTRYWAY.** This shot from the top of the upstairs hallway showcases the front entryway and the beautiful wood stairs. The wrought iron work on the banisters is also a nice textural addition. The shot was lined up so the bottom of the stairs comes out on the left one-third line. The Guided Transform tool in Lightroom was used to make sure the horizontal lines of the ceiling above the door and the stairs were lined up parallel to one another. This is one of those times when the verticals don't have to be straight.

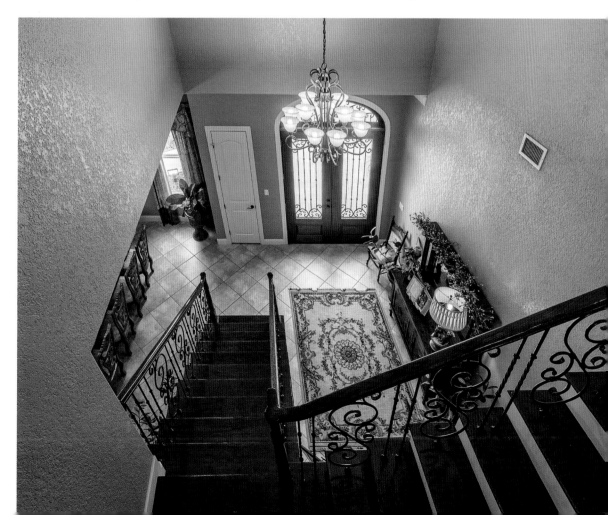

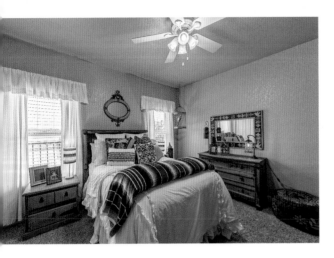

▲ **BEDROOM.** This is a typical children's bedroom shot with two walls converging on the right one-third line. In rooms with bright, saturated colors, it is important to make note of white areas you can use later to establish the proper color balance. In this case, that was easy because the bedspread is white, but sometimes there isn't any reliably neutral or white element in the room. For those situations, it's always a good idea to bring some sort of color balancing card along with you. With the correct color balance selected, look how beautifully the colors pop in this room.

▼ **MAN CAVE.** This is an interior shot of the separate building located beside the home. It was described to me as the ultimate "man cave." I don't think there's any disputing that!

This room represents one of those color balancing nightmares that ends up being a compromise no matter what you try to do to "correct" it. The problem here is that there are so many different sources of light (outdoor/sunlight, fluorescent, incandescent) which dominate multiple spaces within the room. In this case, I chose to correct the overall room color temperature to the area around the pool table, which is primarily incandescent from the fixture hanging down over the table. To my eye, this was the natural focal point of the composition from this angle, so it was important that the color be as correct as possible.

The only other thing I did to correct the color in this image was in the far windows. I corrected that color using the Local Adjustment brush in Lightroom to a daylight balance.

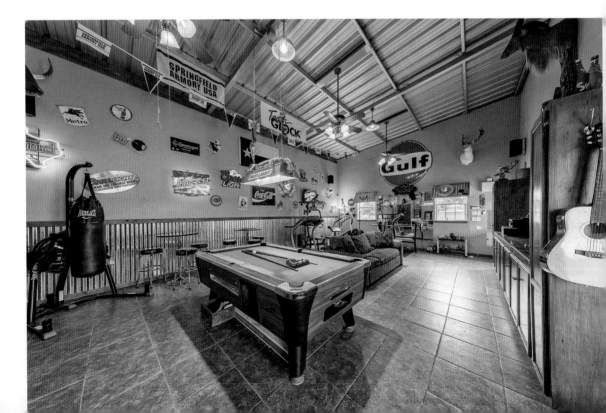

 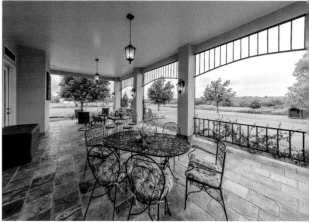

▲ PORCH *(left)*. This shot uses HDR to show the details under the back porch. The wind was light, and the vegetation was limited, so any problems with moving leaves and branches was minimal. This overcast sky also benefited from the Local Adjustment brush in Lightroom set to a –65 color temperature (cool) to give the impression of a bright, partly cloudy day.

▲ BACKYARD VIEW *(right)*. This view is taken from the porch looking out onto the backyard. Once again, an HDR sequence was shot to show maximum detail in all areas of the image. The porch lights were turned on to give a warm touch to the area.

▼ DRONE VIEW. The agent wanted drone images to give an overall perspective on how the home and other structures are situated on the property. Several other angles were shot from above, but this one offered the best overall view. I also used the Self-Guided Transform tool in Lightroom to make sure the horizon line and the horizontal lines of the home were parallel for a more pleasing composition. *Exposure settings: ISO 100, f/2.8, and ¹/₁₈₀ second.*

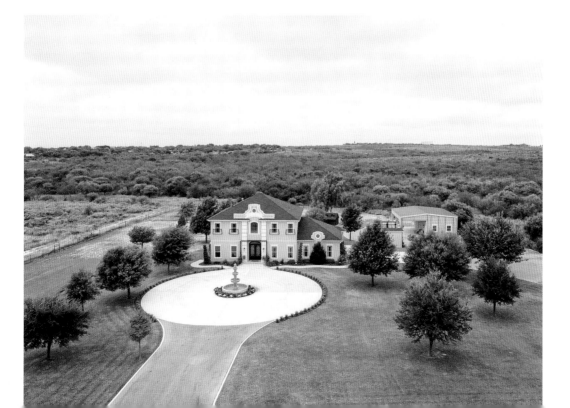

10. SAMPLE HOME 6

▼ **ARCHITECTURAL CHALLENGE.** This view of the front exterior posed a bit of a problem: the right-side front entryway of the home was not designed parallel to the face of the three garages! I had to choose which side to place parallel to the camera, and in this case I chose the right side. When I tried aligning the garage doors with the camera lens, the entryway side was off just enough to look bad. Doing it the other way around, there was a clear enough perspective shift with the garage that it looked intentional.

One other thing to mention is the dead tree showing up on the roof line from the backyard. This tree was struck by lightning about a month before and had been trimmed down to keep it from falling over onto the roof. It could have been easily removed from the image in Photoshop, but since the agent didn't know when the owners planned to remove it, she decided it was best to leave it as it was. *Exposure settings: ISO 400, f/8.0, and 1/600 second.*

Compare this image with the shot at the top of the facing page.

"When I tried aligning the garage doors with the camera lens, the entryway side was off just enough to look bad."

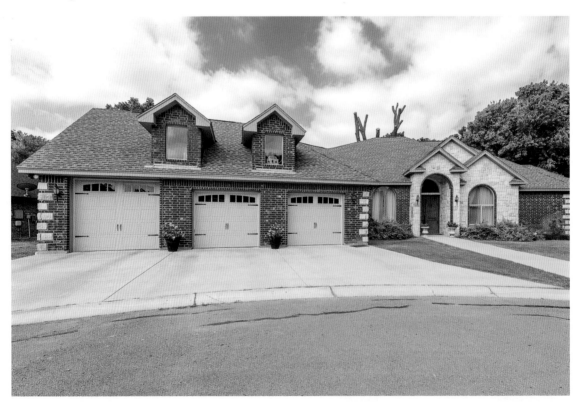

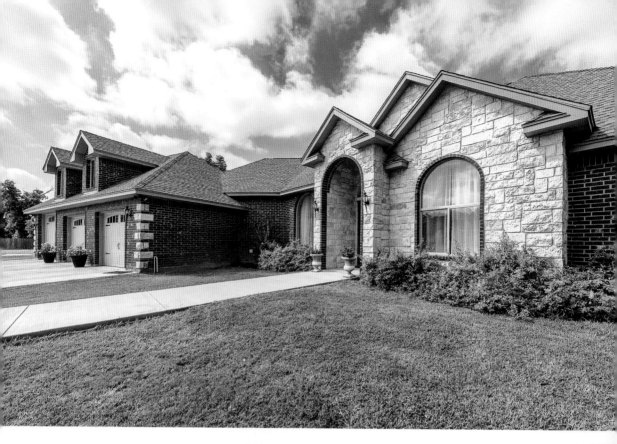

▲ **A BETTER OPTION.** This angle from the entryway side gives a more impactful and pleasing view of the exterior, and was the image chosen by the agent for the listing thumbnail. I brought the camera height down as much as I could so the dead tree didn't show in this image. *Exposure settings: ISO 400, f/8.0, and ¹/₅₀₀ second.*

▶ **THE BACKYARD.** This image of the backyard is derived from an HDR sequence. Since the entire back of the home was backlit at that time of day, it was necessary to shoot multiple exposures to capture detail in all parts of the image. The dominant column of the porch closest to the camera was placed at the right one-third line in the composition. The red umbrella in front of the master bedroom suite was placed on the left one-third point.

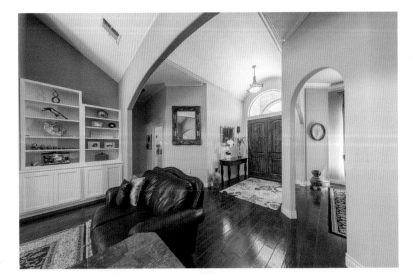

◄ ENTRYWAY. This shot of the entryway was taken from the living room looking back at the front door. The composition is perfectly divided into thirds with the vertical column from the dining area placed on the right one-third line and the vertical coming down from the arched living room entry wall placed on the left one-third line.

▼ MIXED LIGHTING 1. This shot is taken from the left side of the doorway, looking into the dining room. Since the dominant light in the scene is sunlight, I chose to turn off the entryway ceiling light to eliminate any color balance issues. The incandescent light in the hallway was left on to provide separation from the dining room wall and a nice warmth to the image. The original color of that light was intensely orange, so I almost totally desaturated that color with the orange saturation slider in the HSL panel in Lightroom.

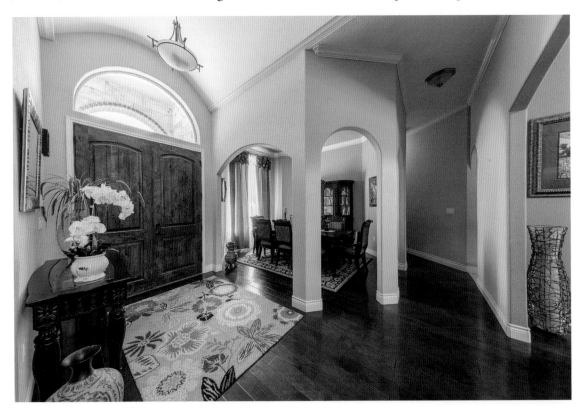

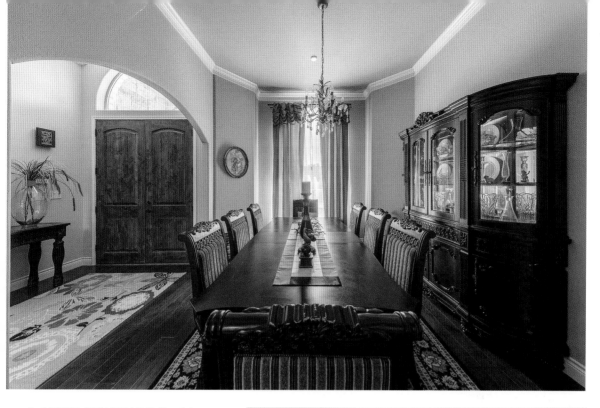

▲ **MIXED LIGHTING 2.** In this view, I turned the entryway light back on to provide a subtle, warm contrast to the cool, gray walls of the dining room. You'll notice that all the horizontal lines were kept parallel to one another by tweaking them with the Self-Directed Transform tool in Lightroom.

▶ **WHOOPS!** I have included this "mistake" to show you how easy it is to miss a big problem in a shot—

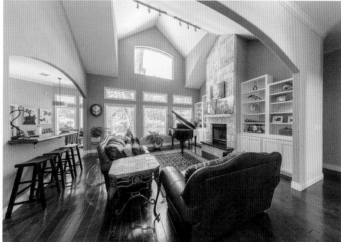

and also to show you (in the next image) that these mistakes can usually be corrected in Photoshop. However, you can save yourself a lot of time and energy by making more than one check of a room this size before taking the shot!

Look at the top image on the facing page again. There, you'll see part of a table in the lower left foreground. The large, clear vase

that's on the floor behind the couch in the above image was originally sitting on top of that table. Since it was partially blocking the view and would have been a big distraction, I took the vase off the table and put it on the floor behind me before shooting the previous image. I then went on to the next shot and completely forgot to put it back on the table!

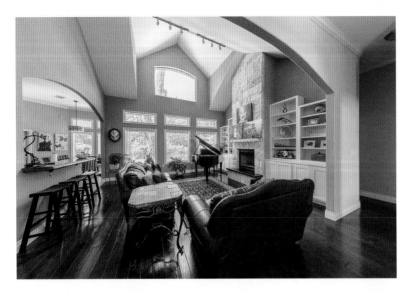

natural light flooding this huge space, any artificial lighting would have been a distraction and would have also created unnecessary color balance problems. I also want you to notice that the exterior has been purposely overexposed by about 1 stop to keep the viewer's attention on the living room interior.

▲ **AFTER RETOUCHING.** This is the "fixed" version of the image at the bottom of the previous page. Removing the vase required some very involved cloning and masking in Photoshop. I had to take several boards in other parts of the floor around the vase, "transform" them to the right shapes, and then mask them into the areas covered by the vase. It isn't perfect, but the fix is virtually unnoticeable to someone who doesn't know the vase was there in the first place!

Here, and in the other living room views, I turned out all the lights. There's so much

▼ **WINDOW EXPOSURE.** Contrast the window exposure in this image with that in the photo above. The windows here are slightly darker, which tends to draw the viewer's eyes out of the room and into the backyard. This isn't always a bad thing, depending on the view. Normally, though, you want the exterior to be just visible enough for the prospective buyer to know it's there, but to not take his/her attention out of the room. The beautiful view here is a selling point, but just suggesting it is enough.

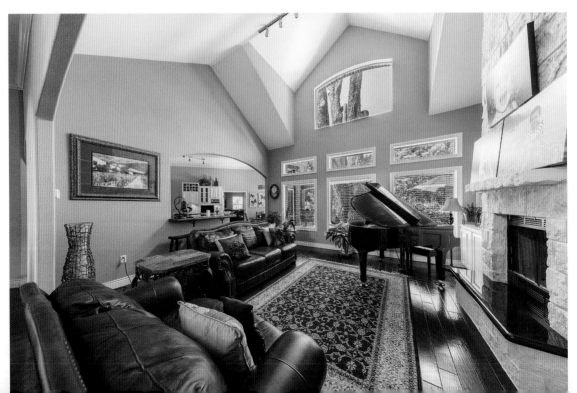

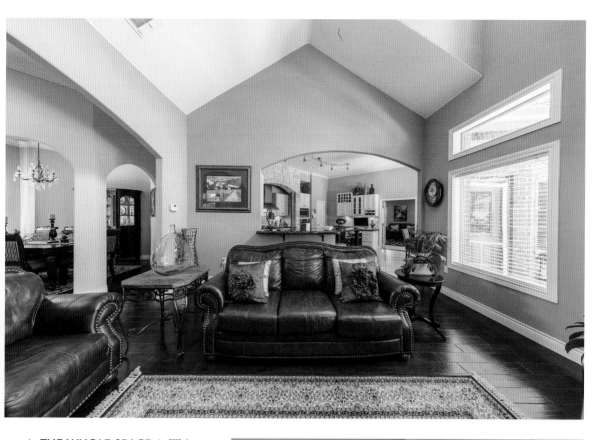

▲ THE WHOLE SPACE 1. This one-point perspective gives us a great view of the entire space even though there is some obvious distortion on the left side of the image. The living room's connection to the kitchen as well as the formal dining room is clearly shown. If you look closely in the distance to the right, there's also a view of an entertainment room located off the kitchen.

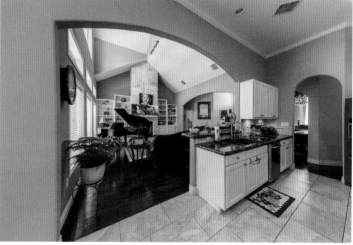

▶ THE WHOLE SPACE 2. This shot looks back at the living room from inside the kitchen and gives another good overview of the layout. Notice a small portion of the formal dining area was included in this view as well. I was conflicted about including the floor mat in front of the bar area, but I finally decided it was a nice addition of color. To preserve the natural sunlit color balance in the living room, I used the yellow saturation slider in the Lightroom HSL panel to tone down the incandescent light coming from under the kitchen cabinet.

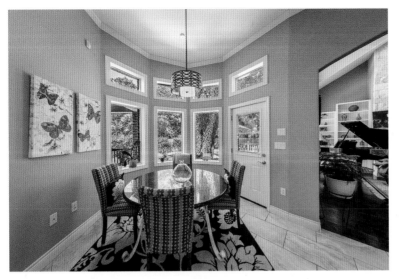

matic here, but notice the picture on the left, closest to the camera. If you look carefully, you can tell it's not straight, but the fact that its left vertical is so prominent and close to the image's frame leaves the impression that the room's verticals are not straight! The eye's natural tendency is to use the vertical line nearest the edge of the frame as the way to line everything up. However, if you try to straighten that edge, you'll see right away that the rest of the room will be out of alignment.

▲ **CROOKED PICTURES.** This shot of the breakfast area is another example where the exteriors in the windows could have been toned down a bit. Also, I turned off the lamp hanging down over the table to eliminate color balance issues. One thing that should be pointed out here, too, is the problem that crooked pictures sometimes pose to a composition. It's not that dra-

▼ **A BETTER CROP.** One way to eliminate this (in post-processing) is to crop in on the side where the vertical is off so that the edge of the painting can't be seen at all.

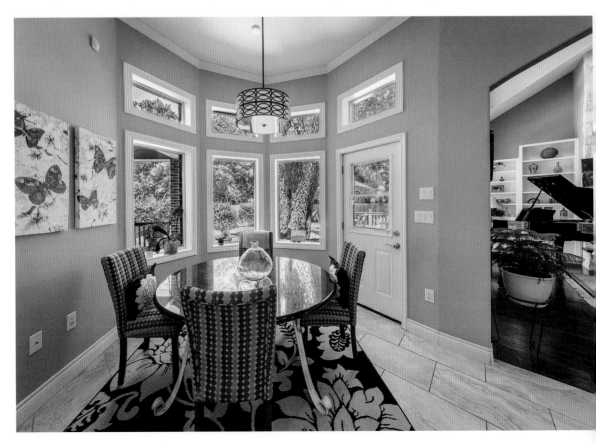

▶ **AN UNAVOIDABLE DISTRACTION.** This view of the kitchen gets it all in and includes the entryway to the home theater/entertainment room. I made sure that the horizontal line of the island's granite top lined up with the bottom of my frame. The tile lines on the floor line up as well, but they have a bit of bowing to them due to some lens

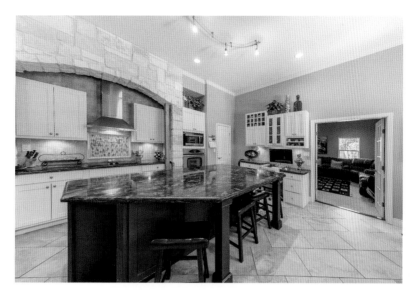

distortion. The big thing to point out here is the piece of wood bracing the edge of the stone archway to the right of the range hood. The owner had recently had a crack in the rock repaired, and he couldn't re-move the brace before our scheduled shoot. Since it was likely to be gone by the time the house was listed, I was asked to remove it in Photoshop. You can see the finished image below.

▶ **REMOVING THE PROBLEM.** This was a very involved fix since I had to create several elements that could not be seen behind the bracing board! To do this, I copied elements that did exist in the image and transformed them to fit. The cabinet door on the right was created by using the right side of the cabinet door to the left of the hood.

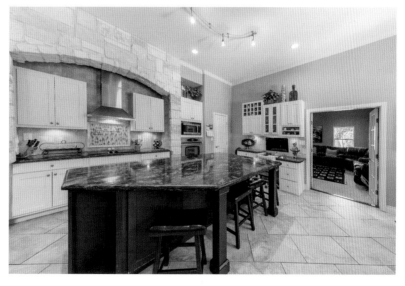

Likewise, the rest of the drawer on the right was made from the right side of the drawer on the left. The Transform tool was used to distort the items into shapes that would fit, and then they were masked in. The rock area to the right of the newly created cabi-net was cloned in bit by bit from what little was already there.

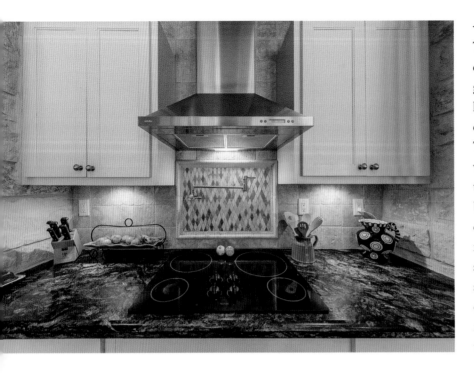

◀ **STOVE HOOD.** This stove hood and cooking area was a great feature of the kitchen that warranted its own close-up. The only thing I wish I'd noticed at the time was that bright red butter dish on the left! I made this composition as perfectly symmetrical as I could, but the dish manages to disrupt that symmetry.

▼ **HOME THEATER.** This is a shot of the theater/entertainment room located next to the kitchen. I wanted to emphasize the size of this room, so I got back as far as I could into a corner and shot toward the opposite corner. This room hadn't been staged as well as the rest of the home, so this angle also kept most of the clutter that was there out of the frame.

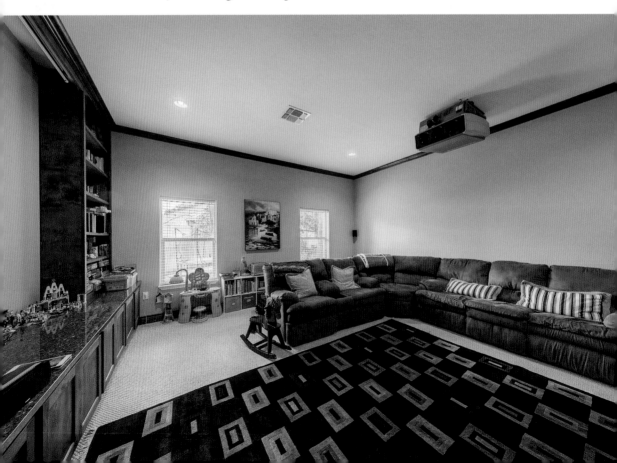

▶ MASTER BEDROOM.

This is a big jump from the kitchen area to the master bedroom suite. Once again, I took advantage of the fact that so much natural light was coming into the room. I left the bedroom lamps and ceiling fan light off to eliminate most of the color balancing problems. However, there was one color cast in this image that had to be eliminated: a light green color that was bouncing into the room from the grass and trees outside the window! This green cast primarily affected the area around the windows and the wall on the left side of the room. I used a combination of the Local Adjustment brush and the Graduated filter to correct the color. By setting the magenta/green slider in the Color Balance panel to a medium magenta setting, I neutralized the slight green cast by "painting" over it.

▶ MASTER BATH. This is
a view from the bedroom hallway into the master bath. Once again, I've used one-point perspective and symmetry to create a strong composition.

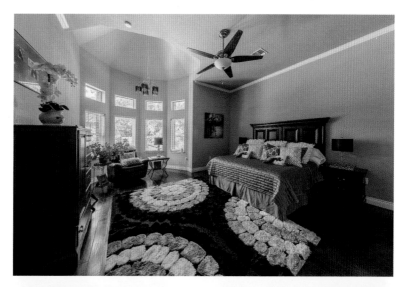

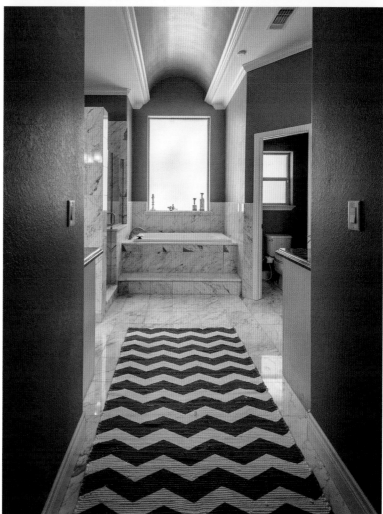

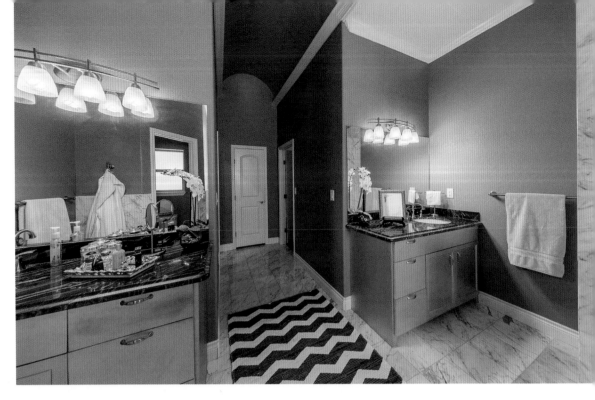

▲ **REVERSE VIEW.** This view is the reverse of the image at the bottom of the previous page, looking back at the door into the master bedroom. Notice the nice detail in the lighting fixtures that helps to soften the overall look of the bathroom.

▼ **SHOWER AND TUB AREA.** This angle completes the bathroom "tour" by including the shower stall and tub area.

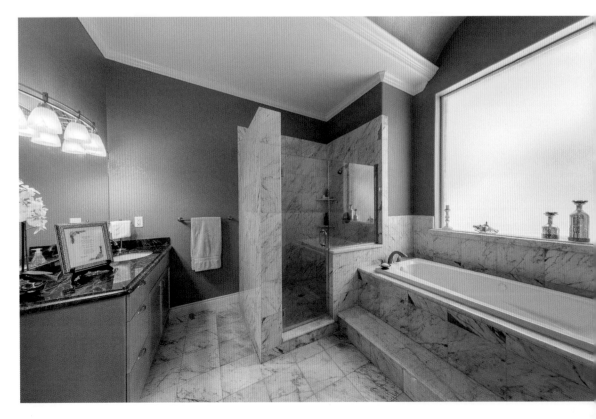

▲ CHILD'S BEDROOM. This is a child's bedroom down the hall. I'm using the same technique I use for most small bedrooms: a two-walled corner angle.

▶ WHAT *NOT* TO PHOTOGRAPH. This is an example of what *not* to photograph in a home! As you can see, it's cluttered and isn't particularly different than most laundry rooms. I like to limit listing shots to those that will get a prospective buyer off the couch and into a home with the agent.

▼ **SAFETY: BEFORE AND AFTER.** This is another child's bedroom and this image (as it is in the top photo) represents something you want to avoid: shooting anything that could possibly identify someone's children to a potential predator. The cabinet has the child's name spelled out in raised, permanent letters. I liked the colors and textures of the letters, so instead of removing them altogether, I just erased two of them (by cloning them out in Photoshop) as shown in the bottom image.

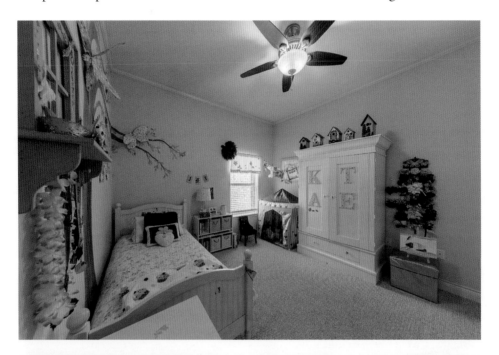

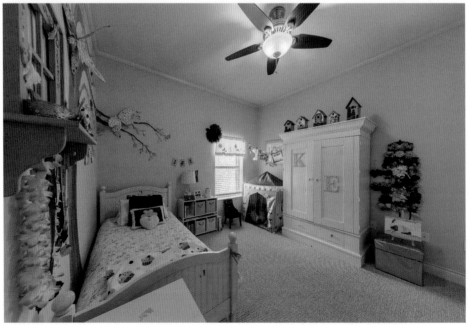

▶ TO THE SECOND FLOOR. This home only had one room on the second floor, but to get that across, I took this shot of the stairs, which includes an element of the room you can see in the next image.

▼ READING AREA. A one-point perspective composition would have looked nice with this room, but it would not have done a good job of showing the functionality of the reading area near the window. By getting this angle with the couch pointing directly to the right one-third area, the combination of leading lines and strong color created a very nice composition.

INDEX